IMAGES
of America

STE. GENEVIEVE

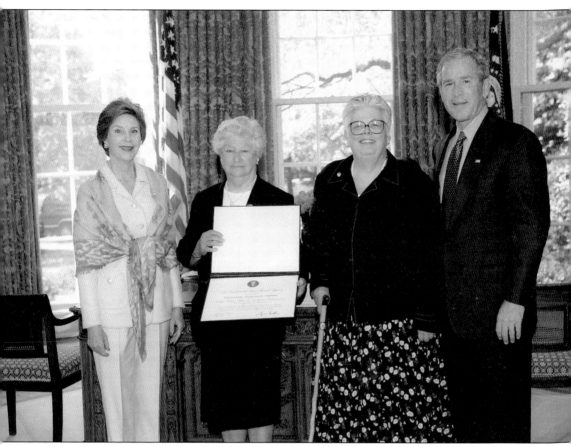

In May 2005, Agnes Chouteau (Pierre), president of the National Society of Colonial Dames of America in the State of Missouri (NSCDA/MO), is with Lorraine Stange, who is a member, as she receives a Preserve America Presidential Award from Pres. George W. Bush for work she has done for the Bolduc House Museum, a national historic landmark, and two other historic houses in Ste. Genevieve. (Lorraine Stange.)

On the cover: Please see page 73. (Missouri State Archives.)

IMAGES
of America

STE. GENEVIEVE

Richard Deposki

ARCADIA
PUBLISHING

Published by Arcadia Publishing
Charleston, South Carolina

Printed in the United States of America

Library of Congress Catalog Card Number: 2007936199

For all general information contact Arcadia Publishing at:
Telephone 843-853-2070
Fax 843-853-0044
E-mail sales@arcadiapublishing.com
For customer service and orders:
Toll-Free 1-888-313-2665

Visit us on the Internet at www.arcadiapublishing.com

*This book is dedicated to the memory of Jim L'Ecuyer,
who introduced me to the wonders of Ste. Genevieve, and to
Albert Montesi, who worked with me on previous books
on historic neighborhoods of St. Louis.*

CONTENTS

ACKNOWLEDGMENTS

This book would not have been possible without the generous cooperation and support of the following individuals and organizations: National Archives; Library of Congress; Jefferson National Expansion Memorial, National Park Service (NPS); National Tiger Sanctuary, Keith Kinkade and Judy McGee; Missouri Department of Natural Resources; Gerald R. Massie Photo Collection, Missouri State Archives and Robyn Burnett; State Historical Society of Missouri; Missouri History Museum; St. Louis Mercantile Library at the University of Missouri–St. Louis, Charles E. Brown; St. Louis Public Library reference department; St. Louis University Archives and Digitization Center, Pius XII Memorial Library; Great River Road Interpretive Center; Ste. Genevieve Museum; Ste. Genevieve Herald; Old Brick House Restaurant; Jennifer R. Clark; Jim Baker; Becky Millinger; Ron Armbruster; William Bader; Jim Beckerman; Bob Mueller; Mike Hankins; Barbara Hankins; Kathy Kreitler; Dena M. Kreitler; Frank Rolfe; Annette Rolfe; Ruby Stephens; Pat Parker; Mickey Koetting; William Hoffman Jr.; Laura Jolley; Erica Yikun Lu; and Randy R. McGuire.

INTRODUCTION

To fully understand the settlement of Ste. Genevieve and its place in North America, we need to understand the international political scene in the 17th century. In 1673, France made claim to a vast region from the Great Lakes to the Ohio and Missouri Rivers. This Illinois Country was governed from Canada. In 1718, the French removed Illinois Country from Canadian jurisdiction and made it part of Louisiana. They planned to extract minerals, furs, and other commodities for trade. Late in the 17th century, French Canadians settled in Illinois Country, to be followed by French from Louisiana as well as France. In the early years of the French presence, they established settlements, such as Cahokia in 1699, Kaskaskia in 1703, Prairie du Rocher in 1722, and others on the east side of the Mississippi River.

By 1720, they had constructed a wooden fort on the east bank of the Mississippi River, 18 miles north of Kaskaskia. This fort lasted until about 1725, when a second one was built farther from the river. The last fort, Fort de Chartres, was built of stone and finished in 1760. On the west side of the river before Ste. Genevieve, there were a number of French settlements, such as River des Peres in the 1700s, Cabanage à Renaudére in 1720, Mine à Renault around 1724, Vieilles Mines in 1726, as well as three in 1723—Mine La Motte, Mines of the Meramec, and Fort Orleans. Large veins of lead had been discovered on the west side of the Mississippi River, and the rich floodplain produced crops for Louisiana. These developments encouraged settlers to move there. France decided that keeping Illinois Country was important for trade and essential for defense.

These French settlers built homes similar to their houses in Canada and in France. Timbers were set vertically into the ground (*maison de poteaux en terre*) with clay, straw, and other materials filling the gaps (*bouzillage*). Stone and mortar (*pierrotage*) were used on other occasions. Later posts were set vertically on stone or wood sills (*maison de poteaux sur sole*).

In the coming years, more French settlements were created, such as Ste. Genevieve around 1749, to be followed by St. Louis, Florissant, St. Charles, and others. Settlers often crossed the "Great River" to the west side to cultivate crops such as corn, cotton, and wheat and to mine the rich veins of lead and to work the streams for salt. With the end of the French and Indian War in 1763, the British controlled the east side, and the Spanish ruled on the west side. The French Catholic settlers began to leave in larger numbers for the west side, preferring to be ruled by a Spanish Catholic king rather than a Church of England ruler.

The great flood of 1785, called *L'année des grandes eaux* (the year of the great waters) by the French inhabitants, destroyed much of Kaskaskia and the tiny village of Ste. Genevieve, compelling the villagers to move farther west out of the floodplain to higher ground. Many residents moved from Kaskaskia just across the river to Ste. Genevieve's new location.

About 75 years after the French settled Ste. Genevieve, Germans comprised the next immigrant wave and left their mark using the abundant clay and limestone for brick buildings and limestone houses. Anglo-Americans, pushing farther west and reaching the Mississippi River in ever-larger numbers, built their horizontal log cabins. Later they put up frame or brick houses, some of which remain today. Little of Creole culture remains in most communities founded by the French, and over the years, many other settlements were abandoned. However, in Ste. Genevieve, one can stroll the ancient streets dotted with 18th-century and 19th-century French houses and savor the ambience of French culture in America.

One

ILLINOIS COUNTRY

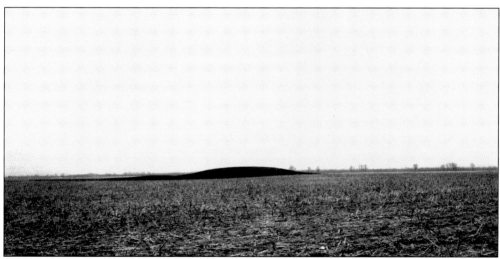

Before the Spanish, French, and British arrived in the region, native peoples had reigned over it for eons. Mounds were built by indigenous groups for religious, social, and civic purposes. This is the largest surviving mound on the common field in Ste. Genevieve. The floodplain, part of the American Bottoms, was near the site of the first Ste. Genevieve settlement. The great flood of 1785 destroyed much of the village—they called it *L'année des grandes eaux* (the year of the great waters). Native American tribes (probably Illinois) and French settlers worked the area for salt, a valuable commodity. French occupied the area around the salt spring shortly after they settled Kaskaskia and continued to make salt until about 1835.

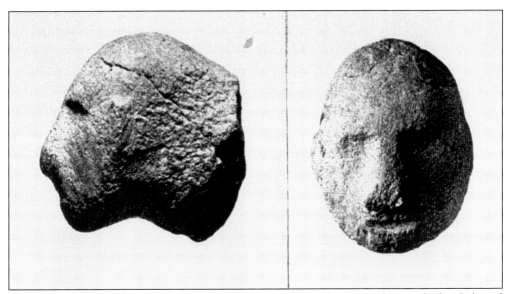

Native American artifacts have been found, such as this small limestone figure, which is believed to be part of a tobacco pipe. The figure was found by researchers in a field that has been cultivated for many years. The field lies close to the salt spring.

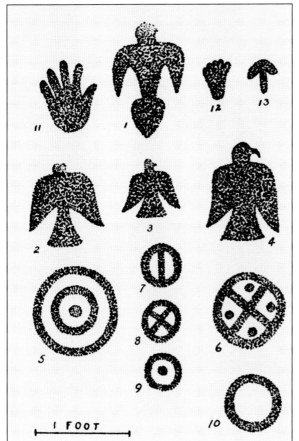

Close to the salt spring, a small cave can be found in a limestone cliff—about 12 feet wide and with a 4-foot-deep channel cut in the limestone by flowing water that continues outside the cave. On the cave floor, 13 petroglyphs were discovered, including bird forms, a hand, a small footprint, six circles, and a figure that might depict the footprint of a bird. Other figures may have been removed. Researchers believe that the petroglyphs date back about three centuries.

This elk bone was used as a hoe and became highly polished with frequent use. The Native Americans were known for using every part of the animals they hunted.

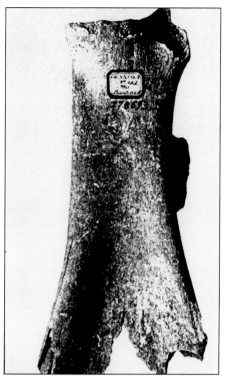

It is believed that settlers in the area dug trenches around salt springs to collect salt-saturated water. The water was then boiled away to leave the salt. Pieces of pottery used for boiling water are found in great numbers near salt springs; a cast taken from a pottery fragment is pictured. Two different types of pottery ware were used by native inhabitants to retrieve salt and for cooking. The first type, shown, had a woven outer surface and a smooth interior.

Large numbers of stone graves were left by Native Americans in the Saline Creek area. Few are known today, however, because of intensive plowing by farmers and digging and looting by artifact hunters. These graves were formed with stones on the bottom, the sides, and the top. The grave pictured here was excavated at the beginning of the 20th century. The limestone pieces were smaller than in most Native American stone graves. This grave was 6 feet long and about 15 inches at the widest point. It consisted of two compartments, a larger one containing a disarticulated skeleton and a smaller one containing only a skull.

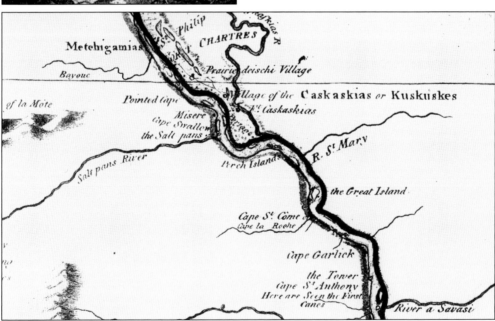

This 1765 French map depicts Illinois Country in relation to the river now known as the Mississippi. The first Ste. Genevieve location is indicated as Misere. In 1785 the village moved several miles to the west. The first permanent European settlement west of the Mississippi River grew out of earlier settlements on the east bank, including Kaskaskia, Cahokia, Fort de Chartres, St. Philippe, Prairie du Rocher, and other smaller sites. The Pioria, Kaskaskia, and Illinois Indians lived in Ste. Genevieve among the French.

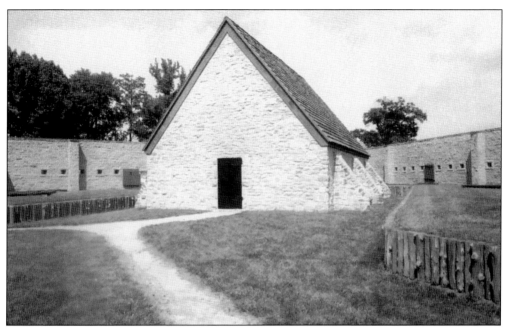

From 1720 to 1763, French settlers governed Illinois Country from Fort de Chartres. Both a commandant and a judge had headquarters here. The first two fortifications were made of wood, and a stone fort was constructed in the 1750s. The powder magazine, pictured, has survived since then and benefited from restoration in the 20th century. Walls and several buildings were rebuilt. British troops took possession of the fort in 1765 and abandoned it in 1771.

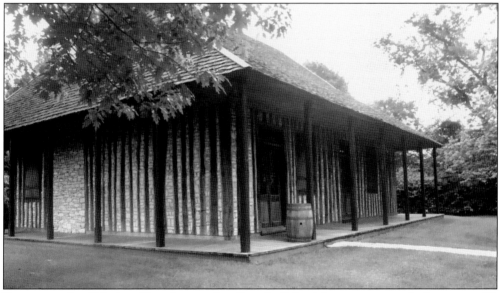

Known as the Cahokia Courthouse, this French Colonial *poteaux sur sole* (post-on-a-sill) structure was built as early as 1740. Beginning in 1790, the building housed the administrative and judicial departments for the region. Before their trip up the Missouri River, Meriwether Lewis and William Clark conducted business here, mailing letters from the in-house post office to Pres. Thomas Jefferson. Pontiac, chief of the Ottawa tribe, was murdered in the vicinity in 1769.

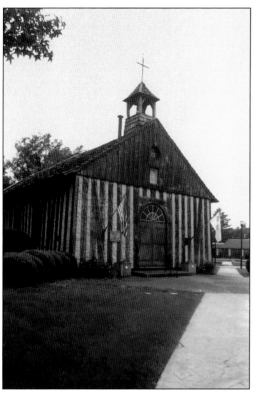

Canadians from Quebec City built their first church, a log chapel dedicated to the Holy Family, at the villages of the Tamaroa and Cahokia Indians in 1699. The church was destroyed by fire in the 1730s. The second wooden structure burned in 1783. This third church, also built of vertical timbers, was dedicated in 1799. Soldiers who fought in the Revolutionary War are buried behind the church.

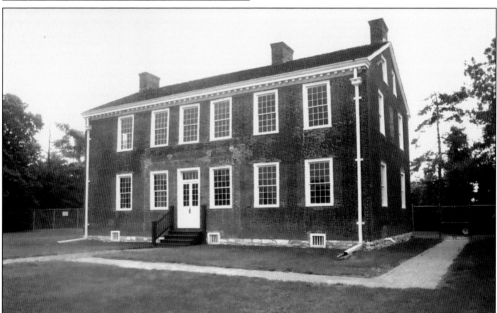

Entrepreneur Nicholas Jarrot and his wife, Julie, built this Federal house between 1807 and 1810—a change from the dominant French Creole style. In the winter of 1803–1804, Nicholas met with Meriwether Lewis, who was preparing to explore to the northwest of the Missouri River. Nicholas translated for Lewis in dealings with French-speaking villagers. Later the Jarrot family established ties in Ste. Genevieve.

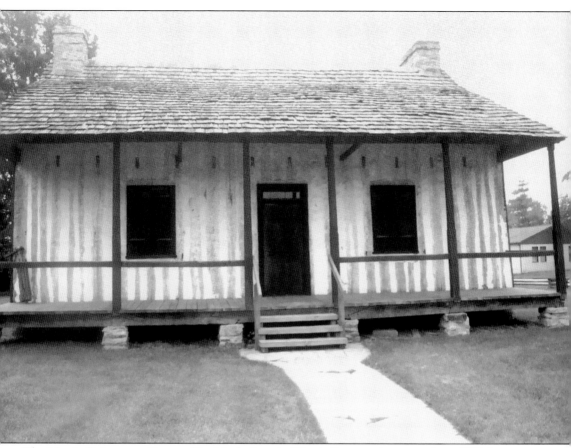

The Martin-Boismenue House of Prairie du Pont in Illinois Country dates to at least 1790. It was built by Pièrre Martin, a veteran of the Revolutionary War. It was hidden behind the additions of many decades, until being discovered in the early 1980s when the owner began tearing down this "simple house" to replace it with a car wash. As the demolition proceeded, a poteaux sur sole Creole house was revealed.

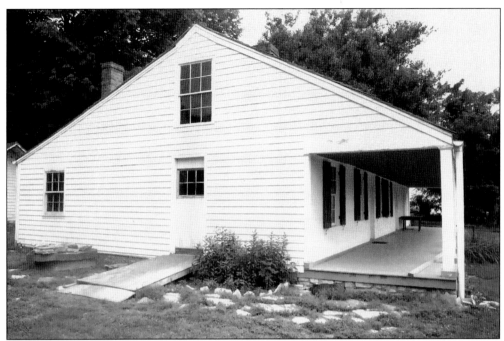

A c. 1800 Creole house stands at Prairie du Rocher, a French village established in 1722. Much of the limestone for Fort de Chartres was mined from bluffs near the village. During British rule, the "King's Highway" ran between Fort de Chartres and Prairie du Rocher. A land survey shows that in earlier years it was called the "Road of Calvary." Three crosses, reminiscent of Mount Calvary, stood between the fort and the village. Two decades later, the first Ste. Genevieve settlement developed a short distance away on the west side of the Mississippi River.

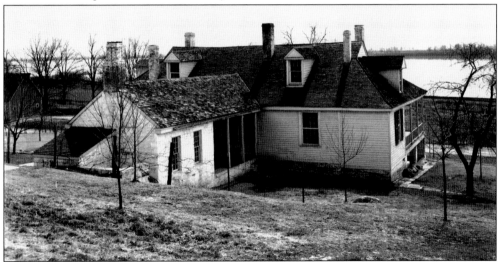

Pièrre Menard, a wealthy merchant, built his house on high ground east of the Kaskaskia River near the village of Kaskaskia. The floods, which finally destroyed the village, shifted the course of the Mississippi River, pictured here in 1937, into the channel formerly occupied by the Kaskaskia River—without damaging the Menard mansion. Kaskaskia was the most important French settlement in Illinois Country. The first civil and religious records belonging to Ste. Genevieve citizens were maintained in Kaskaskia. (NPS.)

Two

PROMINENT FRENCH HOUSES

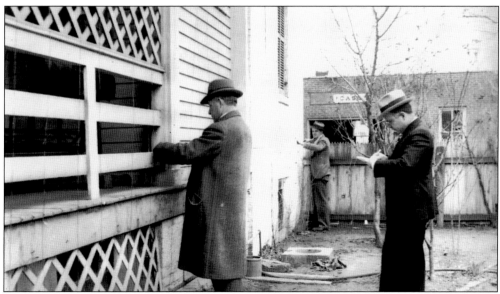

Beginning in 1933, Charles E. Peterson of the National Park Service (NPS) in St. Louis sent architects and photographers to Ste. Genevieve to measure and photograph its surviving ancient buildings. The Historic American Building Survey (HABS) sent teams to many cities and towns throughout the United States. This photograph was taken around 1937. (National Archives.)

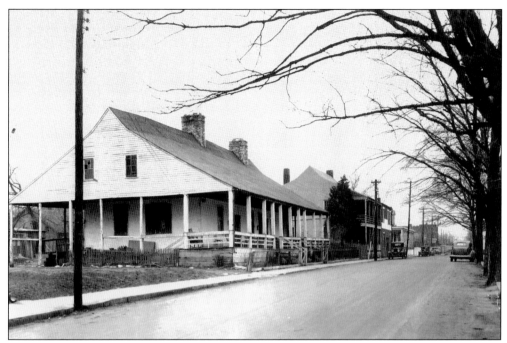

Some say that the Louis Bolduc House is the most authentic and important house in Ste. Genevieve. This HABS picture, taken in 1937, shows the old dwelling after many alterations that have been undertaken through the decades. Louis Bolduc was born in Canada in 1734 and settled in Ste. Genevieve in the 1760s. The house remained in the Bolduc family well into the 20th century. (NPS.)

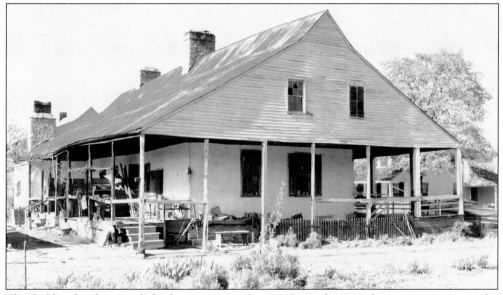

The Bolduc family owned the house, pictured in 1937, until 1949 when it was given to the National Society of Colonial Dames of America in the State of Missouri (NSCDA/MO). This organization began restoration work on the house, hiring Ernest Allen Connally, a well-known architectural historian, to oversee the project. The restored Bolduc House was opened to the public in 1958. (NPS.)

The Bolduc House, shown in 1937, was constructed using the poteaux sur sole method. Timbers were set vertically on a wooden sill supported by a foundation of large stones. A gravel-and-lime mortar mix called *pierrotage* was placed between the timbers. (NPS.)

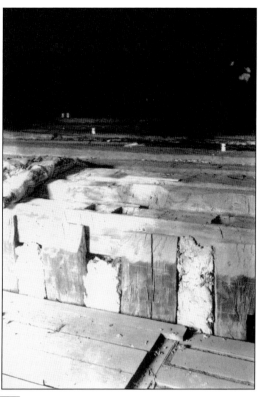

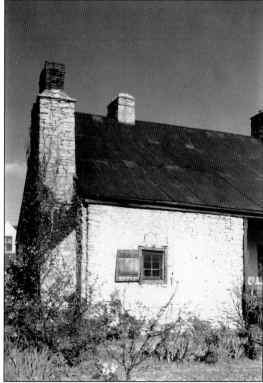

The baking and cooking area in the left corner of the rear *galerie* (porch) were photographed in 1937. At the time of this photograph, the house had not yet been restored to its original appearance. (NPS.)

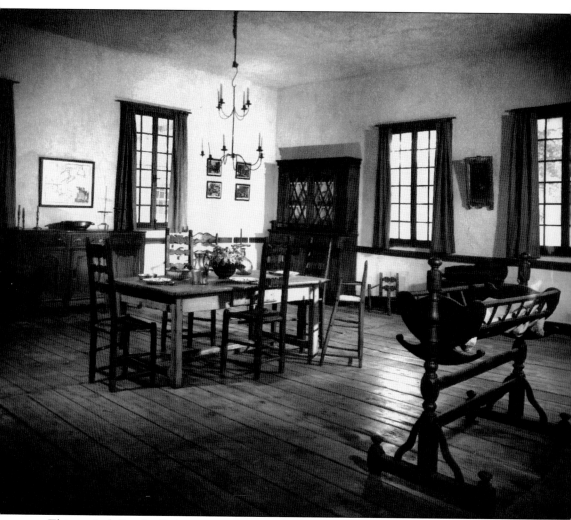

This typical Creole dining room, photographed in 1956, was furnished with a simple table, chairs, and an armoire on the rear wall. A unique baby cradle is seen in the foreground at right. Residents had very little privacy, as related by historian Carl J. Ekberg: "They ate, slept, worked, danced and entertained guests in the same room." (St. Louis Mercantile Library.)

In 1956 and 1957, the Bolduc House was successfully restored to its 18th-century image. A major aspect of the restoration was replacing the gable roof with an original hipped roof. Pictured above is the justifiably proud architect, Ernest Allen Connally, who studied and restored the entire house and grounds to its former glory. (State Historical Society of Missouri.)

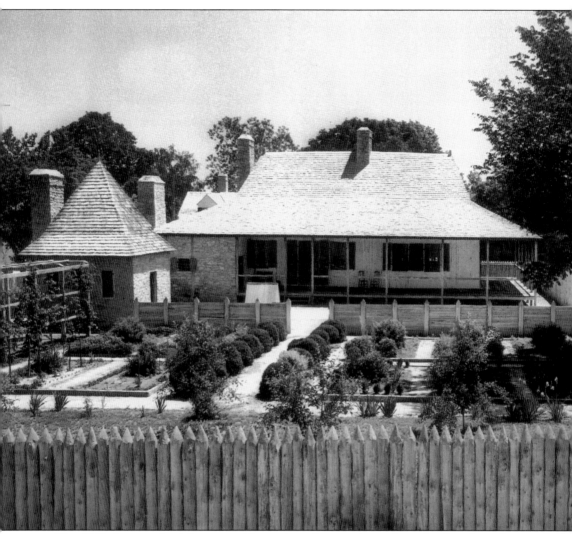

This 1956 photograph of the restored home from the rear shows the cedar-shingle roof, vertical timbers, and the high sharp-pointed fence that surrounds the entire property. The fence protected the residents from animals and intruders such as unfriendly Native Americans. Despite the generally friendly relations between Native Americans and Ste. Genevieve inhabitants, there long remained some fear of attack. (St. Louis Mercantile Library.)

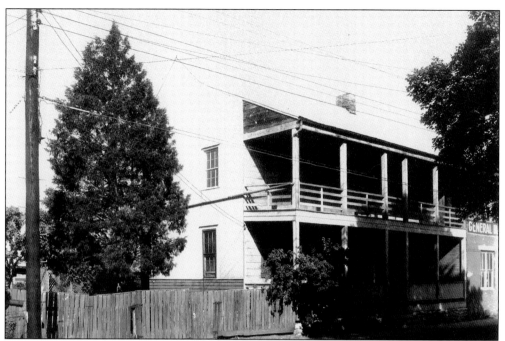

Next door to the Bolduc House sits the Bolduc-LeMeilleur home, an Anglo-American frame building constructed with strong French features. It was built in 1820 by René LeMeilleur, son-in-law of Louis Bolduc. In 1837, it was given to the Sisters of Loretto for use as a convent. They added a second floor in the 1850s. This photograph was taken in 1937. (NPS.)

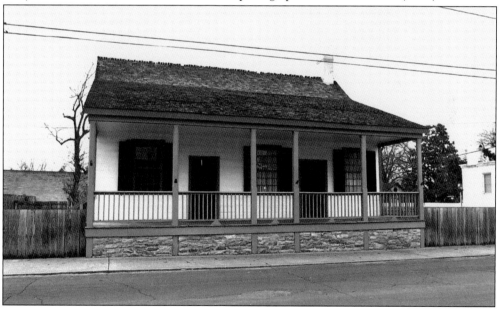

In the 1960s, Ernest Allen Connally led the effort to restore the house to its original 1820 appearance. This photograph shows the house after restoration. The second floor was removed, along with an 1820s brick building next to it. The front and back galleries were rebuilt. Over the years, much had been altered on the house and much was missing from the original construction, which had to be restored.

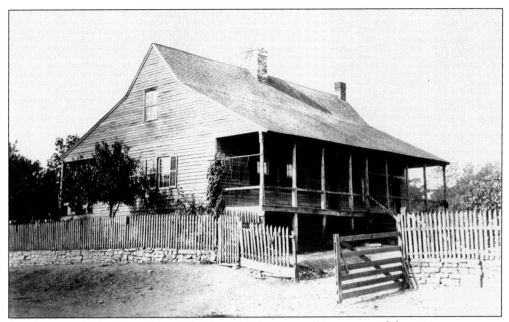

Another gem in Ste. Genevieve is the Beauvais-Amoureux House, one of three *poteaux en terre* structures in town and one of five in the United States, pictured in 1937. The house was built by Jean Baptiste Ste. Gemme de Beauvais around 1792. In the 1840s, it was reduced in size, and a gabled roof replaced the hipped roof. Chimneys were removed and rebuilt elsewhere on the house. There had been numerous changes on the interior. (NPS.)

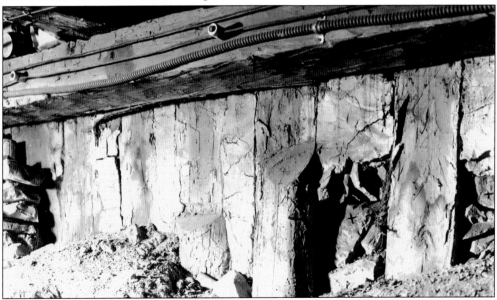

As can be seen in this photograph from 1937, the timbers are set directly into the ground to a depth of three feet with most of the portions sawed square. Mulberry and cedar trees were commonly used for their resistance to rot. Vertical logs braced the truss that supported the roof. A mix of gravel and lime mortar, called pierrotage by the French, was packed between the vertical logs. Sometimes a blend of straw, animal hair, clay, or grass was used in another construction practice called *bouzillage*. (NPS.)

Trusses, photographed around 1937–1938, support the roof. Oak was often used for the trusses of these Creole houses. The Norman truss concept was imported from Normandy by early French immigrants to Illinois Country. (NPS.)

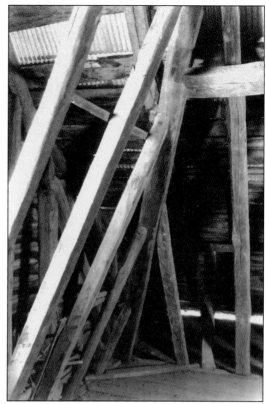

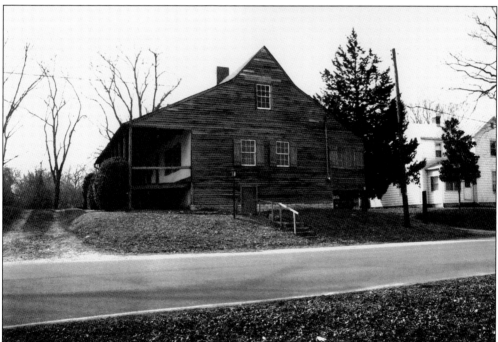

The Beauvais-Amoureux House was built around 1792 and modified in the 1840s. This French log house is a surviving French Canadian construction of its type and period in Illinois Country.

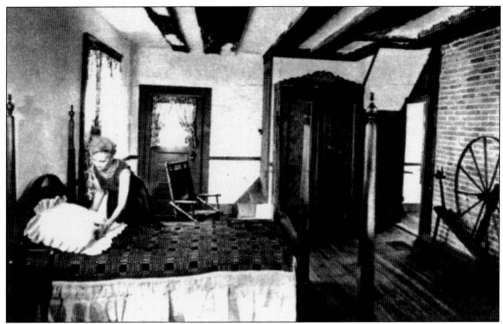

The 1840s brought exterior and interior changes. Norbert and Frankye Donze restored the house in 1963 and opened it for tours. Now the Missouri Department of Natural Resources owns the home and intends to restore it to the 1790s period. (St. Louis Public Library.)

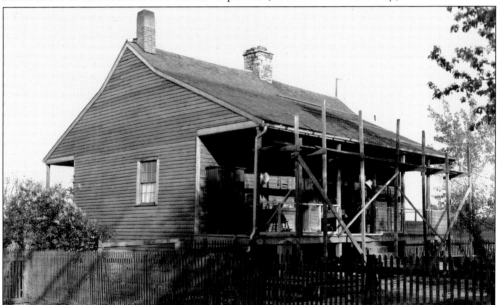

Discussion among experts about the Bequette-Ribault House, pictured in 1938, can stir some disagreement as to its age, whether it was built in the 1770s as some claim, or as late as 1808, as dendrochronology of the house timbers seems to indicate. This Creole dwelling is one of only five surviving poteaux en terre buildings in the country. It stands facing the common field of Ste. Genevieve and the floodplain of the Mississippi River. The American Bottoms provided wheat and corn, among other crops, for the Louisiana Territory under the Spanish and the French. (NPS.)

Either Jean Baptiste Bequette or his family members built this house. Later it was sold to a woman named Clarise, who lived in the house with a John Ribault. It is not known if they were man and wife or even her last name. The Ribault descendants lived here until 1969. This image clearly shows the hand-hewn timbers of the truss. They are mortised and strengthened with wooden pegs. (NPS.)

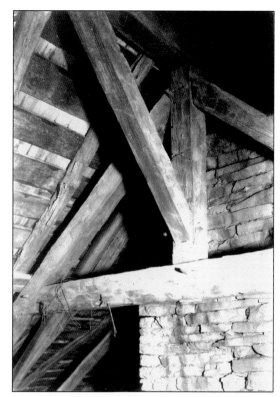

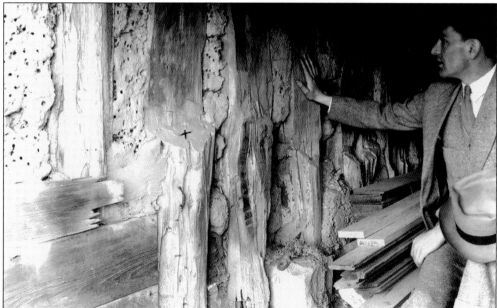

Charles E. Peterson studied architecture at the University of Minnesota and began his career with the NPS in San Francisco. In 1933, he initiated HABS. This survey produced more than 46,500 drawings and 110,500 photographs of historic buildings throughout the United States. Peterson retired from the NPS in 1962. Over the years, he published books on the Mississippi Valley French. This photograph is from around 1938. (NPS.)

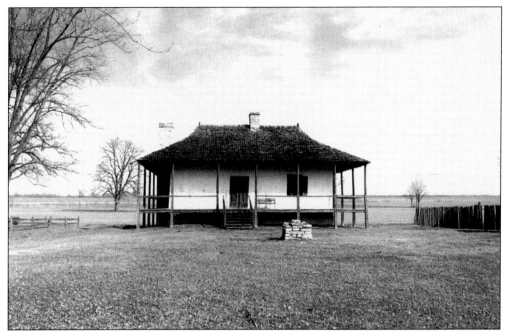

The elevated first floor of the Bequette-Ribault House provides some protection from floodwaters, as it looks out over the common field, typical for French settlements. But the 200-year-old house was no match for the devastating flood of 1993 as it stood in high water for several weeks. Nevertheless, it suffered no significant damage.

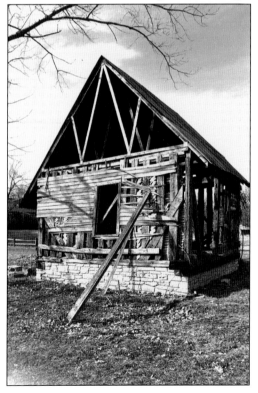

Behind the Bequette-Ribault home stands another ancient but small Creole house. The Lasource-Durand Cabin was moved here from Chadwell Lane in 1983. It too is of vertical-log construction but of the vertical post-on-sill variety. The original cabin was built around 1807 with only one room, but with the addition of a second floor, it became a six-room house. The additions have been removed in recent years.

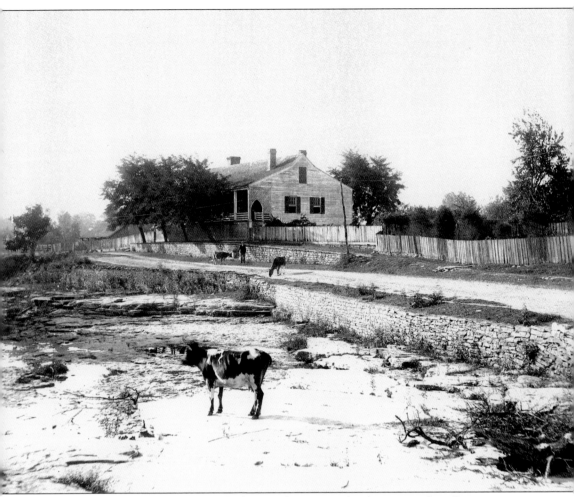

The Nicolas Janis House, photographed around 1870, is also known in Ste. Genevieve as the Green Tree Tavern or Janis-Ziegler House. It is a significant French vertical-log dwelling. Historians have considered the building to be of traditional French construction, while offering Anglo-American comfort and privacy. Its rooms were designed for privacy and rest. It was built with a raised basement to house slaves and to provide additional storage space. It contained living quarters and a business area under the same roof. (Missouri History Museum.)

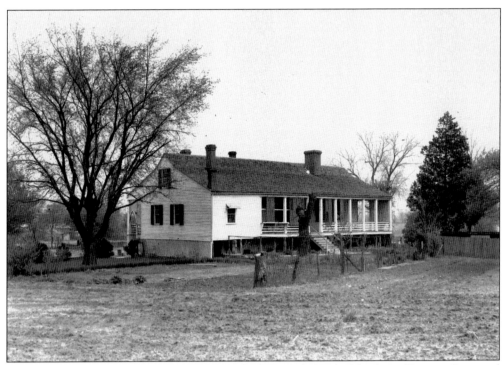

The Creole house, photographed in 1937, was built around 1790 by Nicolas or Francois Janis and sold to Mathias Ziegler in 1833. It housed the first tavern in the Louisiana Territory and became the first Masonic hall west of the Mississippi River, in 1807. (NPS.)

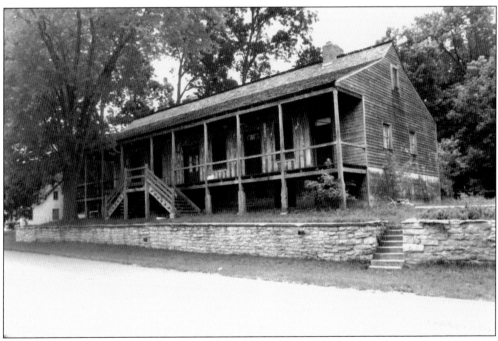

In recent years, the house has been stripped of alterations made over the decades.

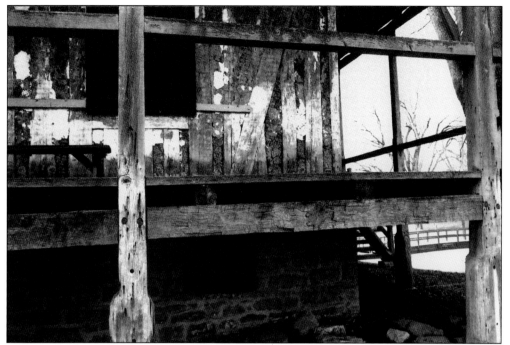

Notice the vertical logs, which are set on a wooden sill, poteaux sur sole. In turn, a stone foundation supports the building. A vertical timber can be seen on a sharp angle, which gives more support to the structure. This was a common technique for vertical timber houses.

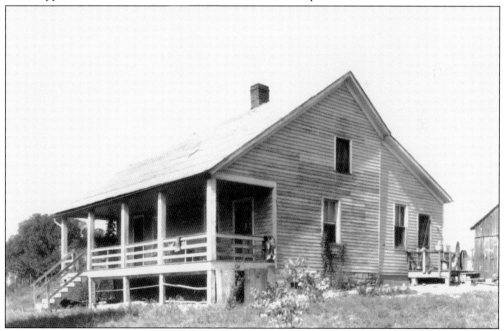

This French Colonial structure, photographed in 1937, was also built (or lived in) by the Janis family. Little information is available on this building, but it appears to date from the early 1800s of poteaux sur sole construction. The room at the back appears to have been created by enclosing the gallery sometime later in the 19th century. (NPS.)

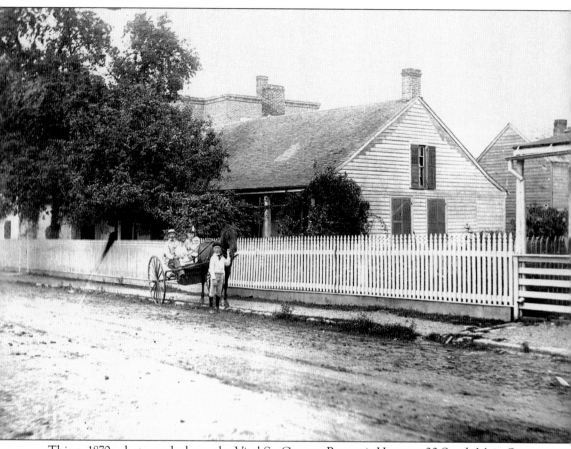

This *c.* 1870s photograph shows the Vital St. Gemme Beauvais House at 20 South Main Street. This structure ranks as one of the most important homes in Ste. Genevieve. It dates to around 1792. Over many years, substantial alterations were made to the exterior and interior of the house. (Missouri History Museum.)

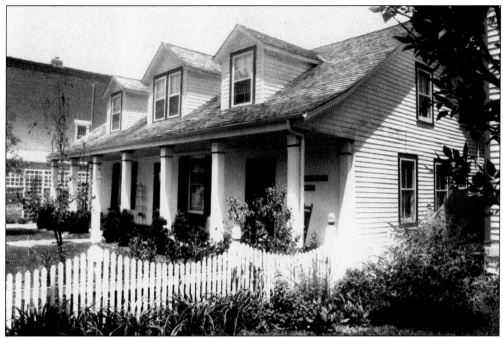

This recent photograph depicts the house behind a Colonial picket fence. The Creole structure is one of the three poteaux en terre homes in Ste. Genevieve. During construction, logs were cut to a pointed end and placed point-down in a three-foot-deep trench that was then filled with tightly packed soil. Norbert and Frankye Donze restored the home, though not to its original appearance of around 1792. It is possible that a complete restoration will be attempted in the future.

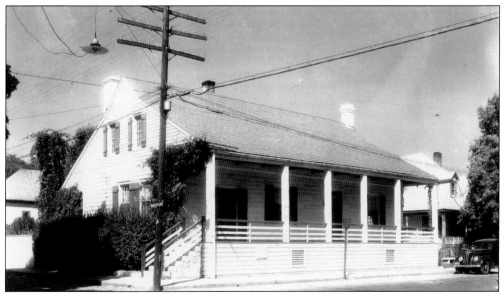

This photograph of the Guibourd-Vallé House, taken in 1937, is dated by the automobile parked in front. Spanish commandant Francois Vallé gave a Spanish land grant to Jacques Jean René Guibourd in 1799. Guibourd took possession of the new home in 1807. The house was owned and occupied by Jules F. Vallé into the 1950s. (NPS.)

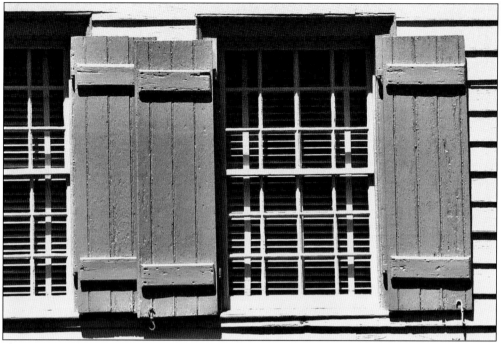

Shutters served to protect windows during strong winds and storms. They also helped to keep out unwanted visitors, such as roaming Native Americans in the early days of Ste. Genevieve.

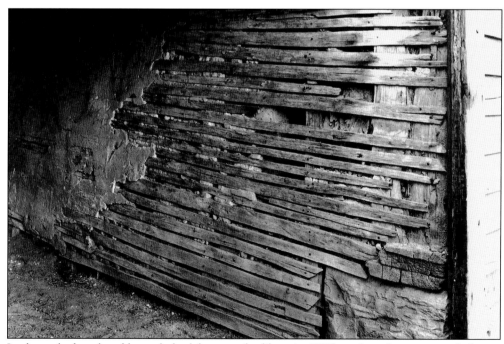

In the early days, hand-hewn laths (photographed here in 1937) used on the exterior of a house were often plastered with lime mortar and then whitewashed. Often cedar clapboards would cover it. Early in the 19th century, machine-cut lath became available, providing a more evenly cut surface to be plastered. (NPS.)

Open access to a second-floor attic allows one to view this Norman truss, photographed in 1937, which supports the roof. The combination of steep Norman roofs and wide porches gave these Creole houses a French and tropical appearance. (NPS.)

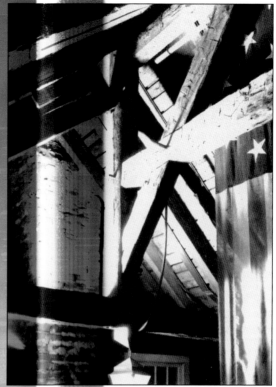

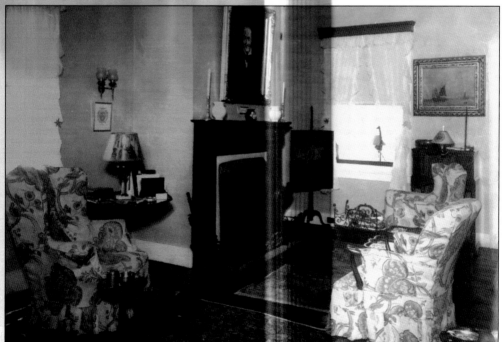

The living room of this home, photographed about 1953, features a portrait of Jean Baptiste Vallé, the last commandant under Spanish rule. The house is maintained by the Foundation for the Restoration of Ste. Genevieve, and it has opened it for tours. (St. Louis Mercantile Library.)

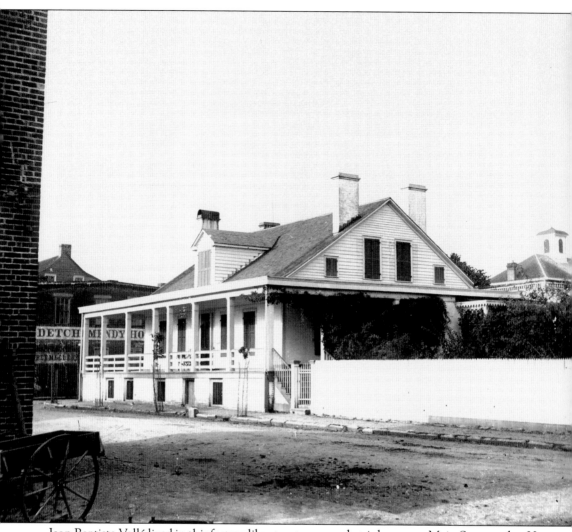

Jean Baptiste Vallé lived in this fortresslike structure, on what is known as Main Street today. He was appointed by Spain in 1804 to the post of civil and military commandant of the district. The building had been the headquarters for Spanish rule in the trans-Mississippi West. The French vertical-log house was built around 1794. This photograph was taken around 1905. (Missouri History Museum.)

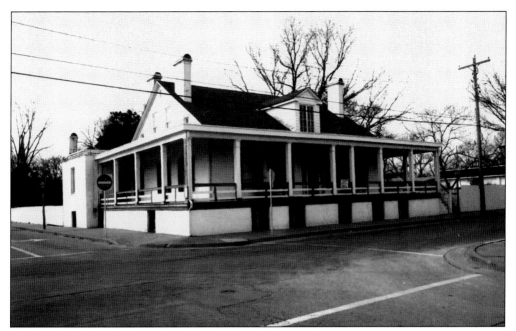

This 21st-century photograph of the Jean Baptiste Vallé House shows little change from 1905. Sometime in the mid-19th century, however, major changes had been made to this French Colonial home. At the time of its construction, the house had more closely resembled the now-restored Louis Bolduc House.

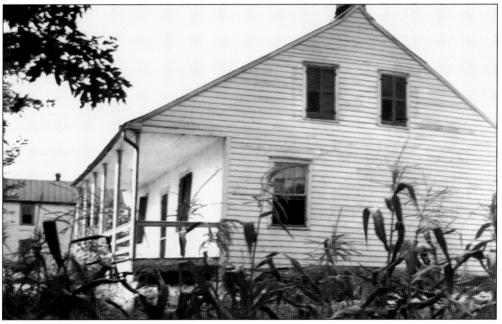

The Basil Misplait House is another important vertical French structure from the late 1700s, but it was demolished in 1956. Missouri Historical Society director Charles van Ravenswaay and Charles E. Peterson of the NPS were disappointed that its demolition was unannounced and sudden, not allowing time to save the historic Colonial structure. This photograph was taken around 1937. (National Archives.)

French wells were often built the same way as their houses. This one, built by the Vallé family, was of vertical boards placed on a wooden sill that in turn sat on a stone foundation. Existing French wells are now rare. This photograph was taken around 1937. (NPS.)

Three

OTHER NOTABLE BUILDINGS

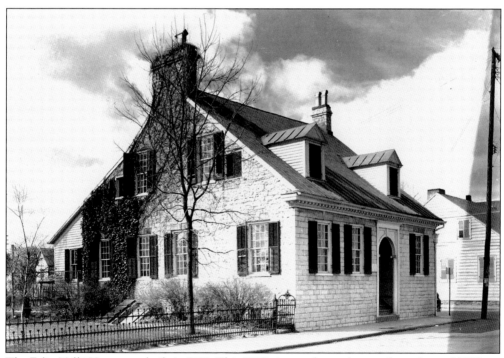

The Felix Vallé House was built in 1818. This 1937 picture shows changes from the mid-1800s to the 1920s. Dormer windows were added, front steps were removed, a cellar entrance was moved from the front and placed on the side, the chimneys were altered with chimney caps, and there were other less obvious changes. (NPS.)

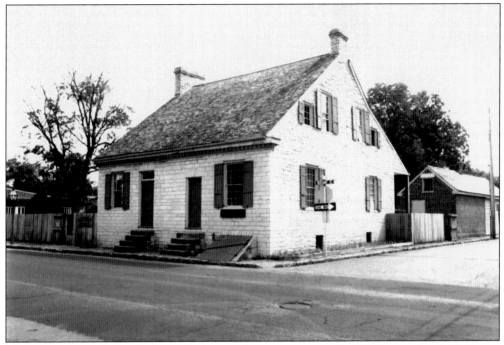

A more recent photograph shows the house after restoration to its 1818 image. Jacob Philipson built it as a residence and business. The Missouri Department of Natural Resources now owns the building.

This staircase at the rear of the house was the only way to the attic. Notice the chamfered posts, an early practice.

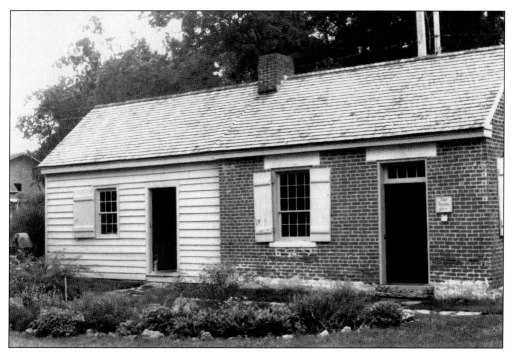

The frame portion of this building behind the Vallé House is believed to have housed slaves, and the brick side served as a washhouse. With the end of slavery, the entire building was used for storage.

Inside the outbuilding is a classic scene. The Vallé family bought the house and property in 1824, and Felix and Odile Vallé moved into the residence. From the mercantile portion of the building, Felix ran Menard and Vallé, a trading firm.

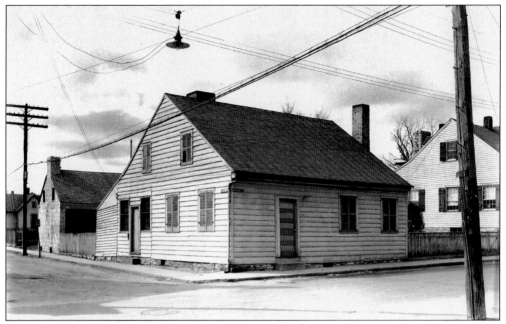

Across Second Street sits the Dr. Benjamin Shaw House built around 1819 by Jean Baptiste Bossier, another prominent resident of Ste. Genevieve. Bossier used the building for his mercantile business. Benjamin Shaw bought the building in 1837 and turned it into a residence. Today it is owned by the Missouri Department of Natural Resources and is used for administrative offices and interpretive exhibits. This photograph was taken around 1937. (NPS.)

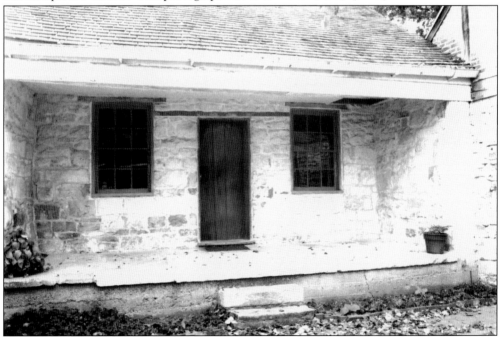

The "Indian Trading Post" built of rubble stone, stands behind the Shaw House. Its original purpose seems unclear to most, but some architectural historians consider that it may have been used as a summer kitchen. It dates to around 1841.

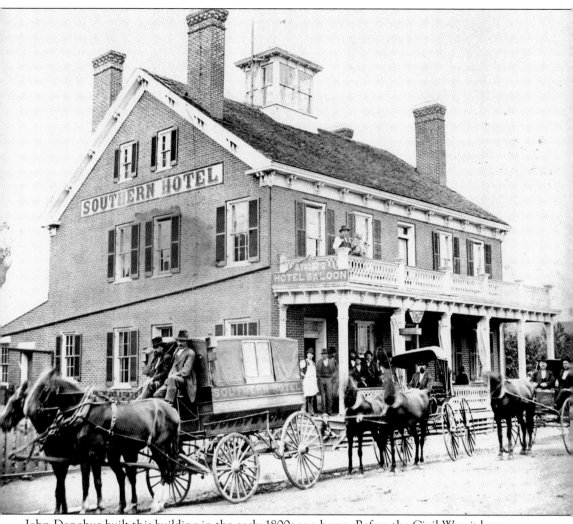

John Donohue built this building in the early 1800s as a home. Before the Civil War, it became the Southern Hotel, which catered to wealthy guests well into the 20th century. It was known along the Mississippi River from Natchez to St. Louis. In 1950, it was converted into an apartment complex. This photograph was taken around 1870. (Pat Parker collection.)

These children are sitting on the Okenfuss Building roof on the corner. Notice the three dormers added to the hotel in the intervening 40 years or so from the time of the photograph on the previous page. This photograph was taken around 1910. (Pat Parker collection.)

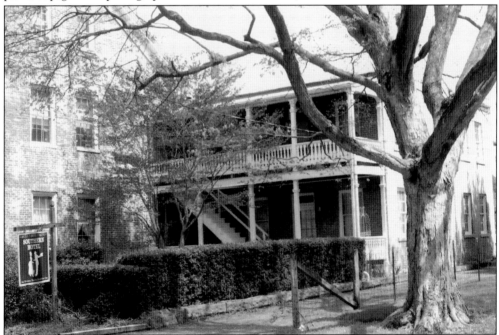

The apartment complex closed in 1980 and remained empty until Mike and Barbara Hankins bought the historic building in 1986. They restored the old home, which had witnessed 200 years of history, and now operate it as a bed-and-breakfast with 19th-century charm. Their business has received national attention through magazines and television.

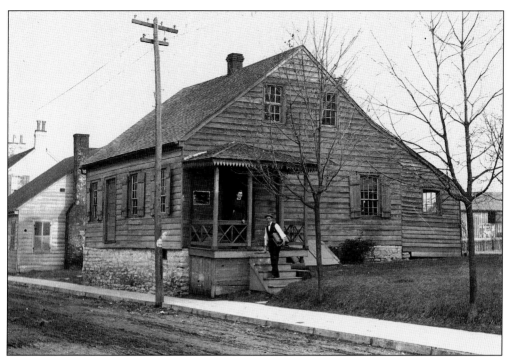

Most architectural historians maintain the Theophilus Dufour House was built in 1837. Tree ring dating confirms this period. Some had insisted that an 18th-century house was on this site and the Dufour House was that same house. This photograph was taken about 1870. (Missouri History Museum.)

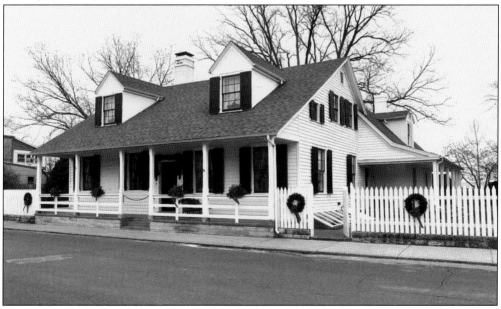

The Gemien Beauvais House is known locally as the Linden House and is now owned by the NSCDA/MO. It is located across South Main Street from the famous Louis Bolduc House. The Linden House is an Anglo-American heavy-timber frame house built around 1813 with some additions and alterations over two centuries.

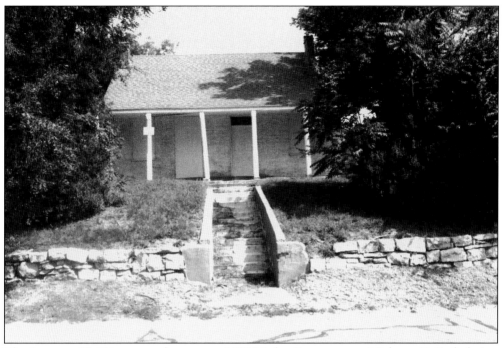

The Augustus Gisi House stands vacant at 1399 Market Street next to Highway 61. Built during the time of the Civil War in a German vernacular tradition, it features two front entrances with a French-style wide and long front porch and a gabled roof. It awaits restoration.

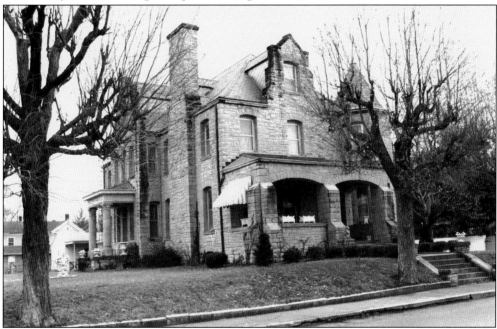

The Judge Peter Huck House at 15 South Fourth Street was built in 1906, replacing the Charles Gregoire House, an 1800 French house of vertical-log construction. The loss of a Creole house is regrettable, but at least this 100-year-old Queen Anne house offers a presence of its own. This photograph was taken in the 1990s. (Missouri State Archives.)

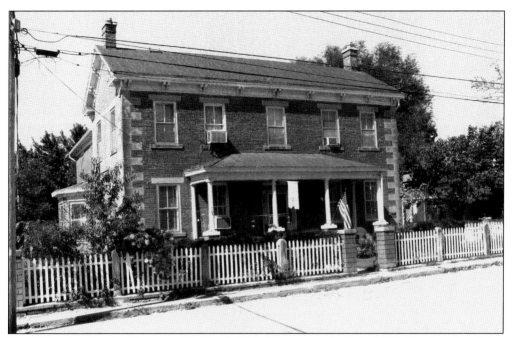

The Valentine Rottler House at 501 North Third Street was built in 1876. The interior of the house, including most of the woodwork, remains mostly original. The transom and sidelights are protected by the hipped-roof front porch. This photograph was taken in the 1990s. (Missouri State Archives.)

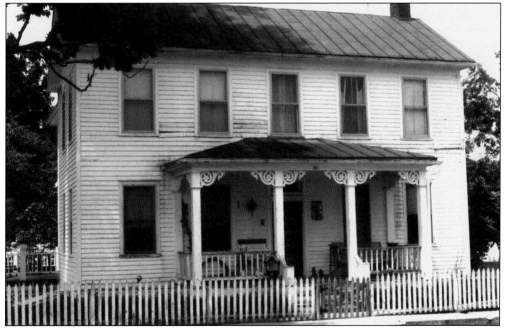

This wood-framed I-house, at 301 Jefferson Street, was constructed around 1900. The windows are two-over-two of double-hung vintage. Clapboards cover the house, and it has a metal roof. The property has two wood outbuildings; one is a shed, and the other is a garage. A picket fence runs along Jefferson Street.

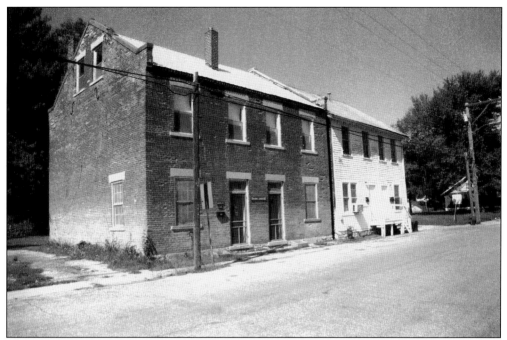

The Christian Leucke House on the left at 341 North Main Street was built around 1865, and the Wendolin Obermiller House was built around 1850. These two buildings, one of brick and the other of wood, are prime examples of early German construction. This photograph was taken in the 1990s. (Missouri State Archives.)

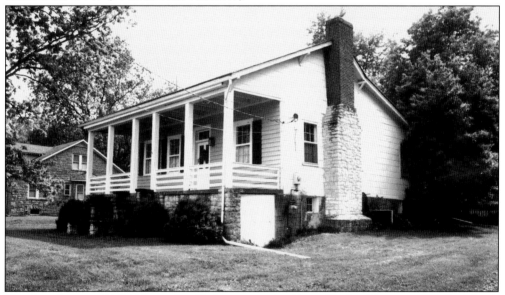

The Jean Baptiste Vallé House, locally known as the Pierre Dorlac House, at 389 St. Mary's Road, is a French vertical-log house with a date of about 1807. Many changes were made since it was built, such as a Greek Revival transom over the front door, window lintels, and a number of others in apparent response to cultural changes in Ste. Genevieve. Pierre Dorlac owned the site in 1790. After he died in 1803, his widow sold the property in 1806 to Jean Baptiste Vallé, nephew of the Ste. Genevieve commandant.

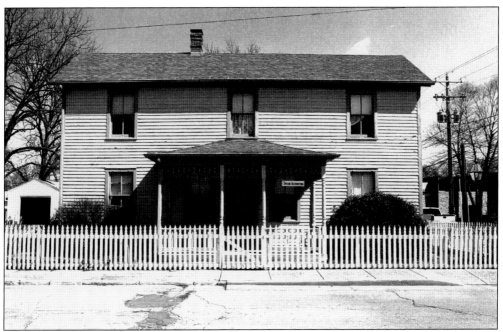

The Jean Baptiste Bossier House is operated as a bed-and-breakfast on Second Street at Market Street in the heart of historic Ste. Genevieve. The front main section was built about 1890.

The rear wing was built around 1818 with chamfered porch posts and six-over-six, double-hung sashes. Alterations have been made.

The Edward J. Bauman House at 355 Jefferson Street was built in 1897. It is a two-story gable front and wing-plan single-story rear ell. The roof is covered in seam metal. A limestone foundation supports the house. The pump in the front yard adds farmhouse charm to the property.

The Etienne Joseph Govreau House at 415 LaHaye Street is a French vertical-log house built between 1800 and 1840. The house has been modified with aluminum siding and a seam metal roof, along with an assortment of different types of windows. An addition sits on a concrete foundation.

Francois Baptiste Vallé, son of Jean Baptiste Vallé, built this Federal stone house in 1835. It is easily one of the more majestic buildings in Ste. Genevieve. It stands on the road to the ferry far from the famous French houses, and many tourists never see it unless they are driving to the ferry. Here it watches over the Mississippi River.

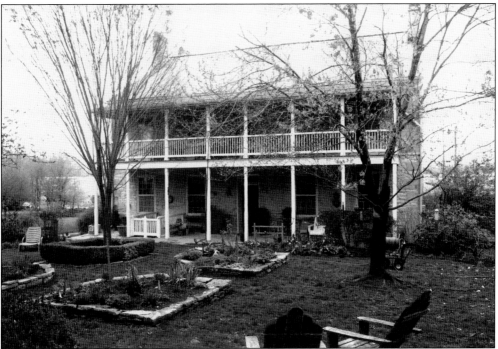

The garden in the rear is of the traditional French formal variety with symmetry. Immediately south of this garden is an informal garden with trees and plants intersected by a primitive path.

The old barn blends in nicely on the northern edge of the garden. A little stone boy figurine appears to be standing guard over the property.

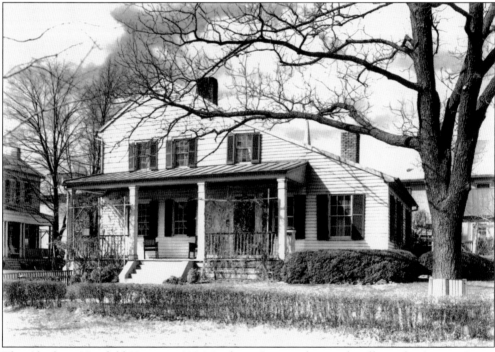

The Abraham Newfield House at 223 Merchant Street is known locally as the Senator Lewis Linn House. Built around 1806, it is of heavy-frame construction. Educated as a medical doctor, Linn represented Missouri in the United States Senate. This photograph is from 1939. (NPS.)

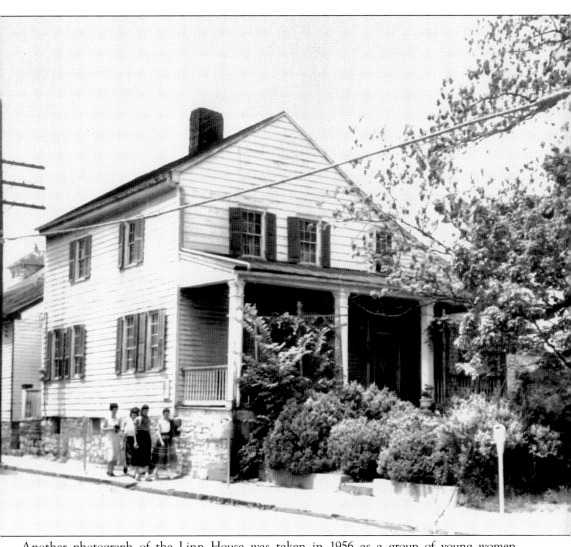

Another photograph of the Linn House was taken in 1956 as a group of young women walk by wearing their "balloon" dresses that were so popular in the 1950s. (St. Louis Mercantile Library.)

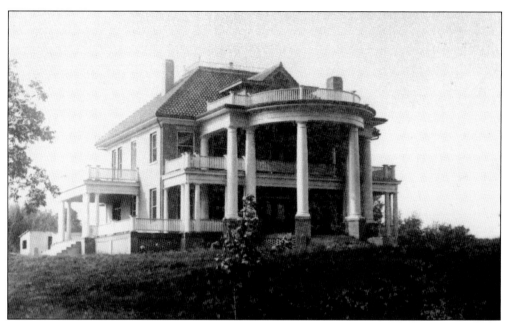

The Ste. Genevieve chapter of the Knights of Columbus serves the community from this c. 1910 Colonial Revival mansion. The beauty of the building on a large piece of land enables it to hold its own in this town famous for its historic architecture. It was built by prominent businessman Jules Petrequin, a part owner and general manager of the Western Lime works. Ownership was passed to Fred and Viola Oberle in 1950. The Knights bought the house in 1959. (Pat Parker collection.)

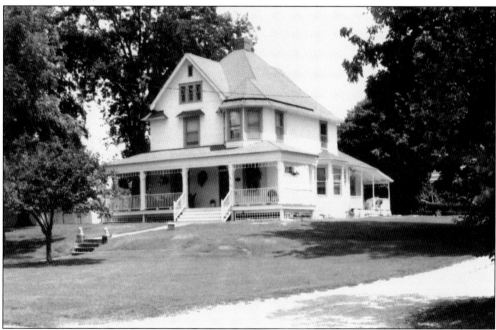

This attractive Queen Anne Victorian house, built around 1900, at 406 North Third Street dominates its part of the neighborhood. The corner tower and wraparound porch are particularly noteworthy. Much of the inside woodwork is original.

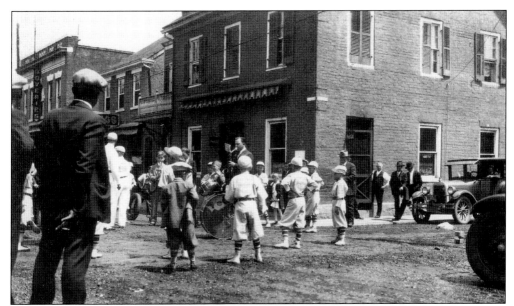

Built around 1804, the John Price Building is reputed to be the oldest extant brick building west of the Mississippi River. It was commissioned by John Price, one of the first Anglo-Americans in Ste. Genevieve. In 1799, he married a granddaughter of Francois Vallé Sr., the last commandant of Ste. Genevieve. Ferdinand Rozier bought the building in 1833. Beginning in the mid-1800s, the Sexauer family owned it for over a century. Today the building is owned by Ron Armbruster. This photograph is from 1931. (Missouri History Museum.)

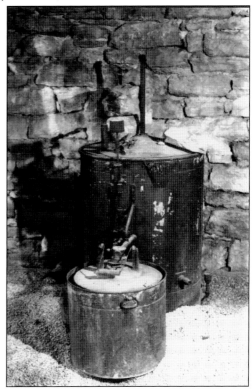

A Prohibition era still can be found in the remote reaches of the cellar. A careful walk down the ancient steps leads one to the magical equipment. Once there, one can feel the thrill and mystery of making the brews that were banned.

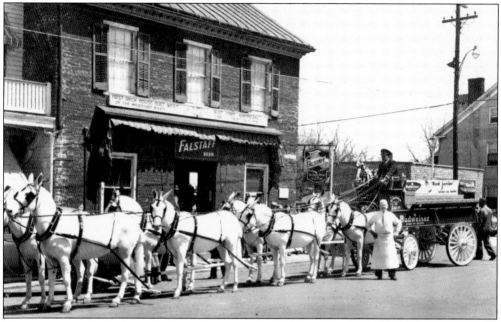

For many years, the building has been known as the Old Brick House, a restaurant with friendly service, good food, and moderate prices. The Anheuser wagon and horses and Falstaff label certainly are evidence that Prohibition was in the past. This photograph was taken in the 1950s. (Ron Armbruster collection.)

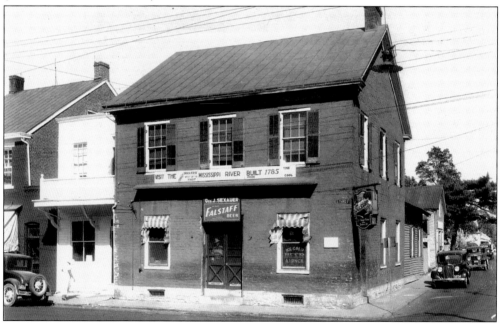

The HABS series of photographs covered many of the historic buildings in Ste. Genevieve, including the Price Building. The Piaget family of photographers and historian Charles van Ravenswaay were part of a team that surveyed and photographed historic Missouri buildings. Also there were survey teams that covered other regions of the country. This photograph is from 1937. (NPS.)

On North Fourth Street, this distinctive stone house with red shutters can be found. It is the Simon Hubardeau House built around 1817. Jean Baptiste Hubardeau, Simon's father, and his wife had moved from French Canada to Ste. Genevieve early in its history. The building is now a guesthouse with overnight accommodations and cooking facilities.

This colorful house on Jefferson Street, built on a terrace across from one of the Vallé schools, has a *c.* 1910 date. The roof of the stoop is supported by wood box columns. The one-story addition on the northwest side of the original block was built years later. Today the house is a bed-and-breakfast called Somewhere Inn Time.

This c. 1915 two-story bungalow, at 403 Jefferson Street, features two-tone bricks and stained-glass windows. A porch covers the length of the south side and wraps around to the east side. This porch roof is supported by wood posts set on brick plinths. La Dee Marie Bed and Breakfast occupies the house.

Felix Rozier, son of Jean Ferdinand Rozier, built this mansion in 1848–1849. Frankye and Norbert Donze restored it in the late 1940s and opened the Inn St. Gemme Beauvais. The Donzes also restored the Vital St. Gemme Beauvais House, Green Tree Inn, Beauvais-Amoureux House, and the Dr. Charles Hertich House. Their place in Ste. Genevieve history is secure. In early 2008, an electrical short caused a fire that did extensive damage to the ancient building; the owners intend to restore it.

Dr. Charles Hertich administered to Winnebago Indians in Minnesota before moving to Ste. Genevieve in 1851. His house sits on Main Street on the left, and looking north, other 19th-century residences and businesses can be seen. The Hertich House is operated as a bed-and-breakfast near one of the most historic areas of the town.

Ste. Genevieve Winery at 245 Merchant Street offers tastings, sausages and cheeses, and assorted gifts. The Chateau Bed and Breakfast occupies the second floor. Wine making is a tradition in Ste. Genevieve. French inhabitants made wine in the 18th century, Germans in the next. Wineries include Charleville Vineyards, Cave Vineyards, Crown Valley Winery, and Chaumette Vineyards and Winery.

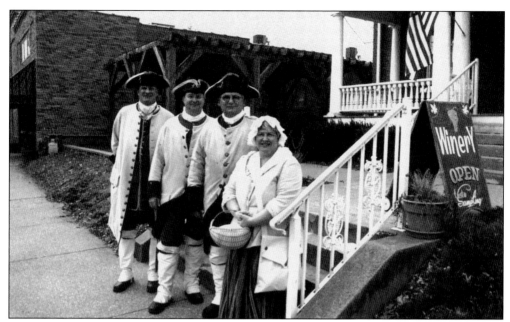

French habitants pose in front of Ste. Genevieve Winery. Many celebrants wore 18th-century garb during the Spring into Ste. Genevieve festivities. Events were scheduled throughout the day. They included gardening presentations, open houses, exhibits, and lectures. Celebrations held throughout the year include Jour de Fête and the colorful French Christmas open house in December.

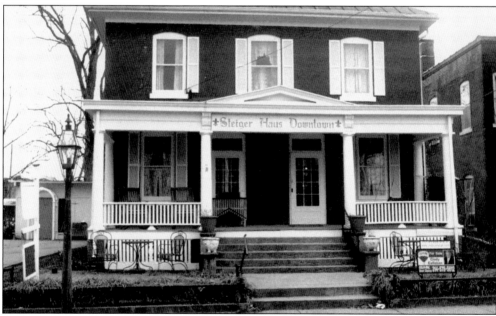

Steiger Haus Downtown is a popular gift shop at 242 Merchant Street. A small outbuilding of the Ferdinand Rozier House is attached to the main section of the Steiger Haus. This outbuilding was built around 1810, whereas the house itself was built about 1910. Murder mystery overnights are performed for guests. A few other bed-and-breakfasts include Main Street Inn, John Hael Gasthaus, and Steiger Haus Homestead.

The Emile Vogt House at 234 Merchant Street was built around 1880 as a gable front, wing-plan house. It now supports Treasured Memories, a well-known gift and tourism business.

The Vital Beauvais House was built in 1799. Later Joseph Pratte, who had commercial ventures in Ste. Genevieve, including a warehouse, owned the house. This stone French Creole house, seen here in 1937, was dismantled to be assembled later. (NPS.)

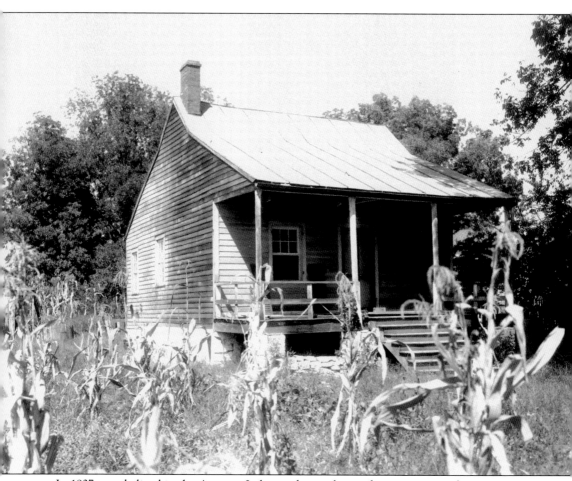

In 1937, people lived in the Antoine Lalumondiere cabin and grew crops on the property. Years later the cabin was bought by the Foundation for Restoration of Ste. Genevieve, to be saved for restoration efforts in the future. Today the early-1800s poteaux sur sole cabin is empty. It seems to be hidden away on a side street where it sits alone almost as an outcast. The roof appears to be intact along with cellar joists and its vertical-log walls. This dwelling is considered by historians to be the best example of a small French house. (NPS.)

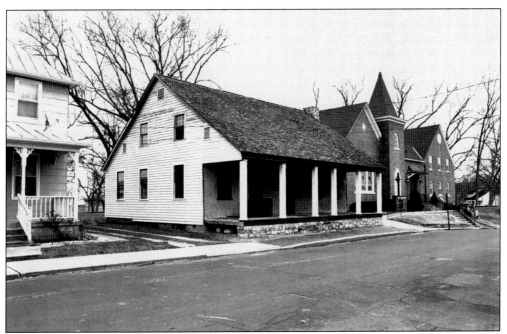

The Antoine O'Neille House, an Anglo-American structure, at 150 South Main Street was built around 1810–1820. The French vernacular influence on non-French buildings is readily seen in this house with the recessed front porch and a possible rear porch, which has been enclosed. An examination by University of Missouri researchers after it was damaged by a fire in 1982 revealed that the half story was added sometime after its construction.

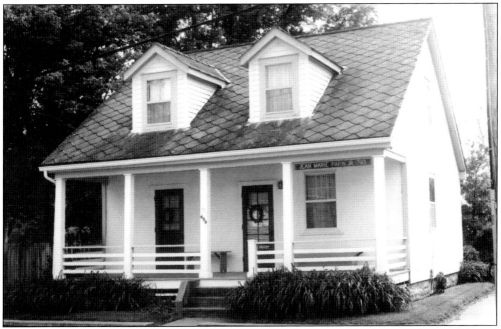

The Jean Marie Pepin La Chance House is another French vertical-log house. This small house at 699 North Fourth Street was built around 1800–1806. Nicholas Lionaise (Villainase) sold the property in 1809 to Jean Marie Pepin Jr. Originally it was a one-room cabin with walls of logs.

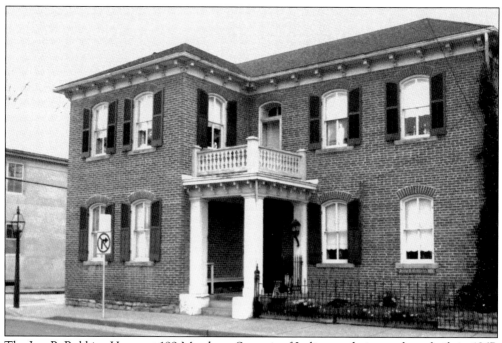

The Jess B. Robbins House at 199 Merchant Street is of Italianate design and was built in 1867. Today the home is owned by the Bader family. It stands across Merchant Street from the Felix Vallé House and across Second Street from the Dufour-Rozier Building.

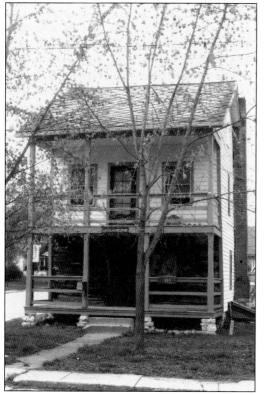

Here is the Louis Delcommune House at 199 LaHaye Street, just north of the more famous group of Creole houses. Although the second floor appears to be of later construction than the first level, some historians say that the entire structure was built around 1850, and others maintain that a horizontal log first floor predates the second level by 50 years.

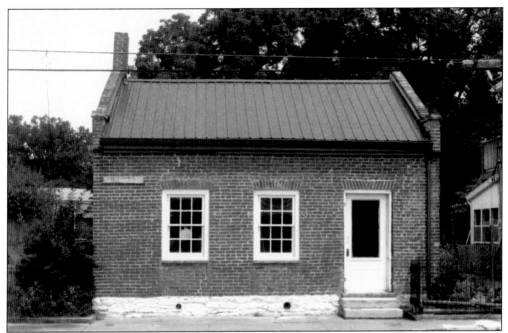

The Martin Intress House at 52 North Third Street is the oldest remaining German vernacular building in Ste. Genevieve. Limestone rubble supports this ancient brick house. Restoration is an ongoing project as multilight windows on the front have replaced other window types. The house was built somewhere between 1842 and 1846.

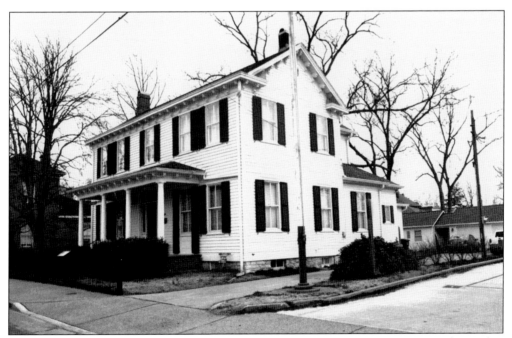

The first construction of the Joseph Bogy House at 163 Merchant Street was around 1810, but the main block was built around 1870. At one time, it housed a restaurant. It blends in well with other historic houses and commercial buildings.

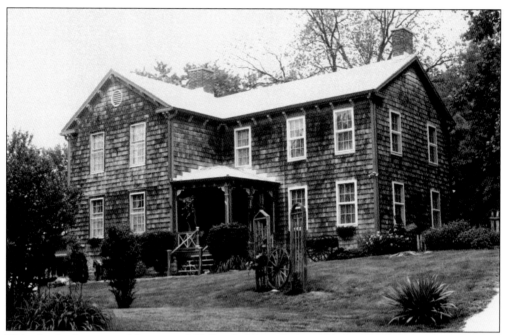

This Anglo-American I-house at 207 South Main Street sits proudly above Gabouri Creek, comfortably safe from any floodwaters. Built between 1806 and 1812, it was the home of Aaron Elliot, and it is believed to have served as a post office in the distant past.

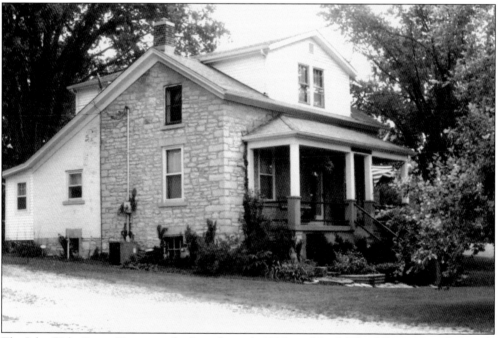

The John Birke Stone House was built in the early 1800s on North Third Street near the North Gabouri Creek, which often threatens the house with flooding, along with others in the area. The original stone building has been added to and altered over the years. This photograph clearly shows many of the alterations.

Although this building is most often identified with Francois Vallé, Henry Keil, an influential business leader in the early 1800s, actually built the house in 1814. This Anglo-American brick and stone house is occupied by the Foundation for Restoration of Ste. Genevieve.

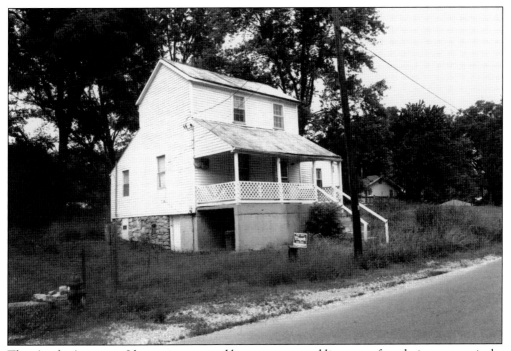

This Anglo-American I-house is supported by a concrete and limestone foundation, respectively. The house and the Brooks House next door together represent the remains of what use to be a black enclave in this 300 block of St. Mary's Road.

Another French house, the Auguste Aubuchon Cottage, photographed in 1937, is not as famous as some other French houses in town, but its poteaux sur sole construction and its early-1800s origins make it important. It resides on Washington Street across from the "Old Academy." The family ancestry leads back to Jean Aubuchon and Jeanne Gillis of St. Jacques de Dieppe Normandie, Marchand, France, in the 17th century. (NPS.)

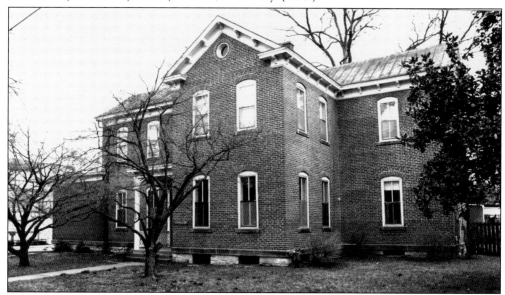

The Leon Yealy House, 406 Jefferson Street, was built around 1887. This brick Italianate building across Fourth Street from Vallé Schools makes a strong presence. Fr. Francis Yealy, a Jesuit priest, was born here. He had a prominent teaching career at St. Louis University as a professor of English literature, and in the 1930s, he wrote a book on Ste. Genevieve and published other books as well.

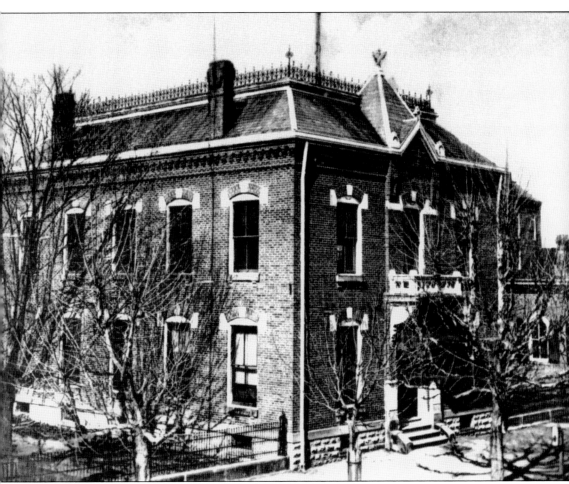

The Ste. Genevieve County Courthouse at 51 South Third Street is an Eastlake public building designed by noted architect Jerome B. Legg. This 1940s photograph shows the 1885 building and a south addition constructed in 1915; a west addition was constructed in 1986. The additions retained the scale and detailing of the original buildings. Legg also created building designs for other Missouri county seats. (Pat Parker collection.)

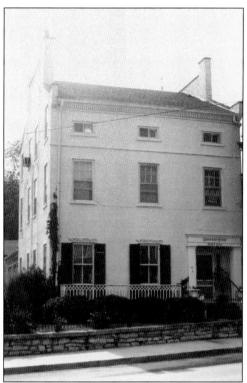

The Gregoire House at 47 South Fourth Street has a date of 1852–1861. Most of the original interior remains, including Doric mantelpieces, are also in the Govreau House, Hertich House, and Rottler House. A side front door and hall plan is unusual for Ste. Genevieve.

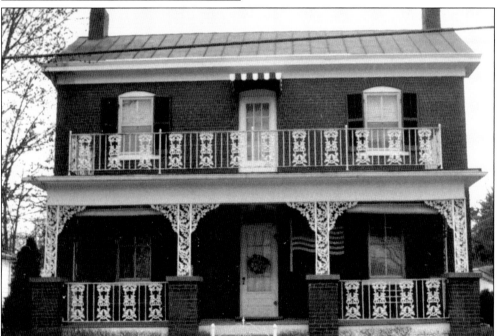

This Italianate house on North Fourth Street was built around 1880 and is known locally as the Sucher House, but it was also owned by the Bahr family, residents of Ste. Genevieve since the mid-1800s. Its wrought-iron posts, which rise from brick plinths and balustrades bring attention to the house.

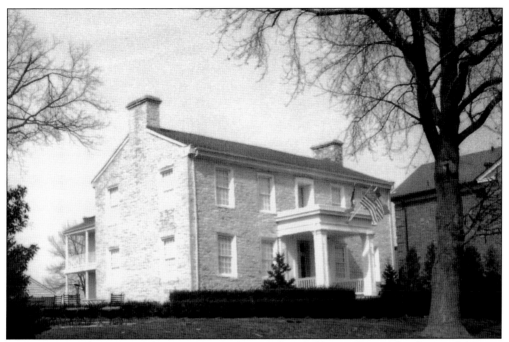

Louisiana Academy opened in 1808 to educate the children of poor families and Native Americans, but it closed several years later. In 1819, the Christian Brothers opened it as the Ste. Genevieve Academy, and it closed in 1822. This was the first educational effort by the brothers in the United States. The building was abandoned in 1823 and sat empty and deteriorating until Gen. A. Rozier restored the building in 1849.

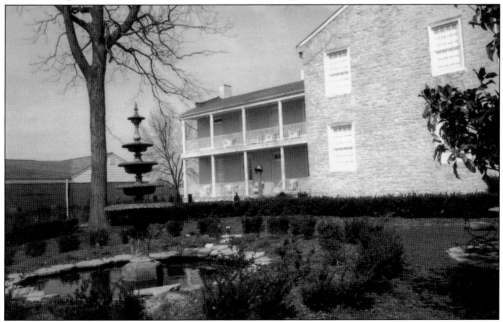

In the process of restoring the structure, he added this brick wing to the ashlar stone original. In 1854, Rozier revived the Ste. Genevieve Academy, but closed it in 1861 when four of its teachers joined the Confederate army during the Civil War.

After the war, Gen. A. Rozier closed the Ste. Genevieve Academy and turned it into a home for himself.

Timothy G. Conley, a pioneer in the restoration of Lafayette Square in St. Louis, bought this endangered building in 1994 and over a five-year period restored it to a state reminiscent of the Rozier achievement of 150 years before. The dining room is furnished in elegant 19th-century antiques. The Rolfe Family Residential Trust bought the building in 2005. Frank Rolfe, his wife Annette, and their daughter Eva Mae now make their home in the former school. Guided tours are available.

Four

STREET SCENES

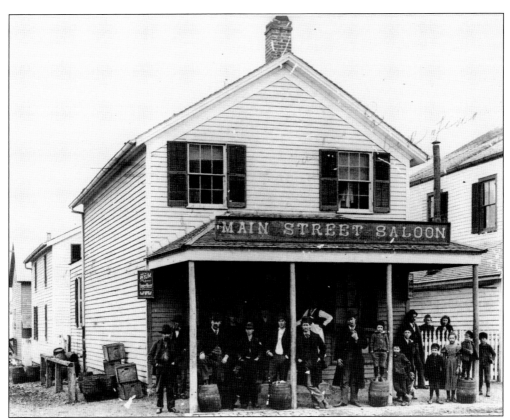

Patrons and those women and children who happened to be there pose in this 1891 photograph. In those days, only women with a reputation would have stepped inside a saloon. Notice the posts for horses. The owner of the saloon probably hired a professional photographer to take this picture. (Missouri State Archives.)

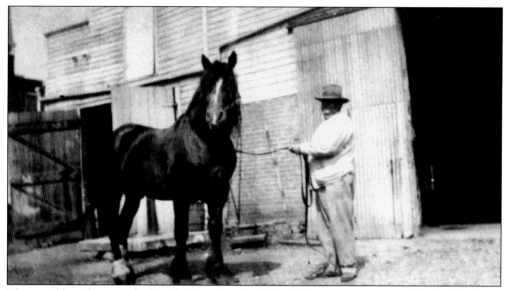

These stables, photographed in the first decade of the 20th century, were used by the Southern Hotel across the street. The man holding the reins is tentatively identified as Joe Vorst, a longtime resident of Ste. Genevieve. (Pat Parker collection.)

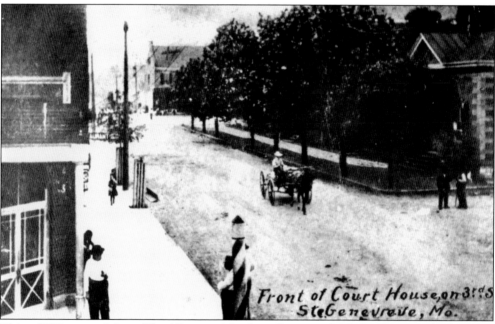

This c. 1900 postcard shows Third Street at Merchant Street, with Market Street in the distance. (Pat Parker collection.)

This photograph was taken during a transition period, 1914–1915, when automobiles were becoming more numerous and horse-pulled wagons and carriages were still prominent. (Pat Parker collection.)

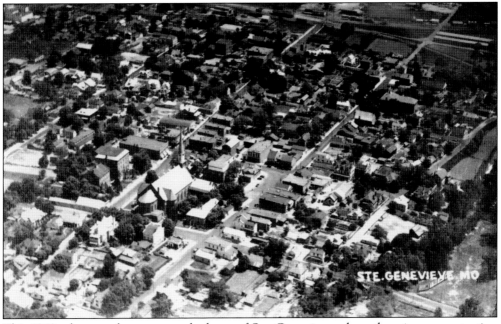

This 1940s photograph centers on the heart of Ste. Genevieve, where there is a concentration of historic buildings. (Pat Parker collection.)

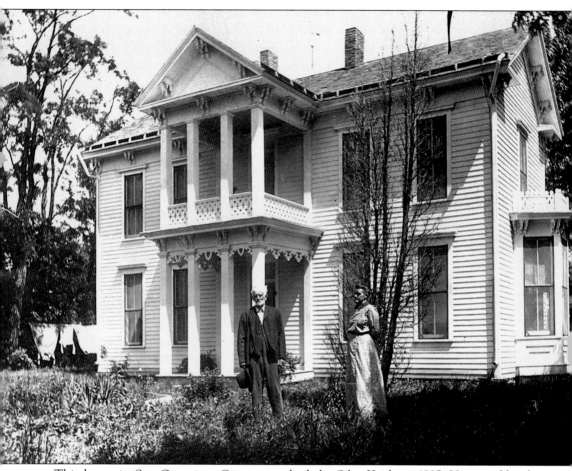

This house in Ste. Genevieve County was built by Silas Keith in 1885. His granddaughter Martha married Stephen Douglas Jacobs in 1887. (State Historical Society of Missouri.)

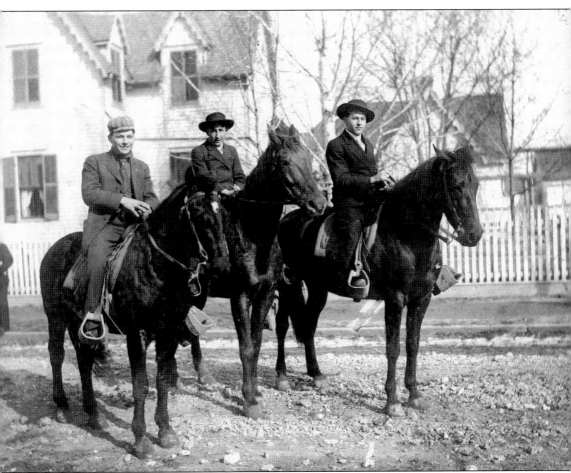

These residents, mounted for the ride and photographed around 1908, are, from left to right, George Huck, Louis Coutris, and Fred Oberle, who was the grandfather of Pat Parker, who still resides in town. (Pat Parker collection.)

This building in this scene is thought to be a detached kitchen belonging to a house owned by Moses Austin, of Missouri and Texas fame. Stephen Austin, his son, led settlers to Texas, achieving his father's dream. The house is owned by the Jour de Fête Committee, which sponsors the yearly festival celebrating the founding of Ste. Genevieve by the French.

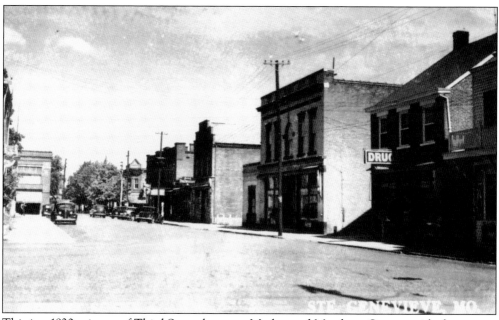

This is a 1930s picture of Third Street between Market and Merchant Streets, with the county jail and courthouse across the street. (Pat Parker collection.)

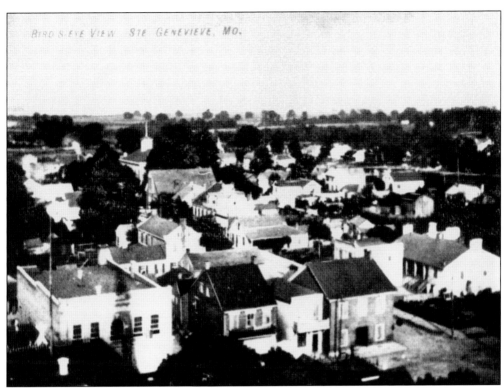

As the caption notes, this is a bird's-eye view of the town, with Third Street in the foreground and the Price Building on front right. This 1940s photograph might have been snapped from the steeple of Ste. Genevieve Catholic Church. (Pat Parker collection.)

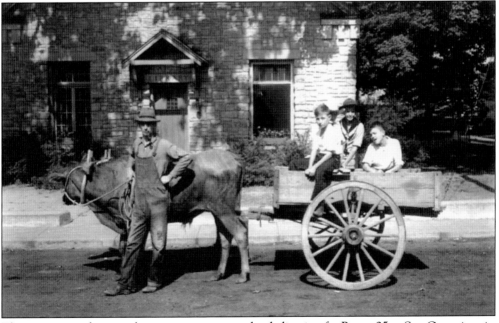

This ox team and cart makes an appearance at the dedication for Route 25 at Ste. Genevieve in July 1941. (St. Louis Mercantile Library.)

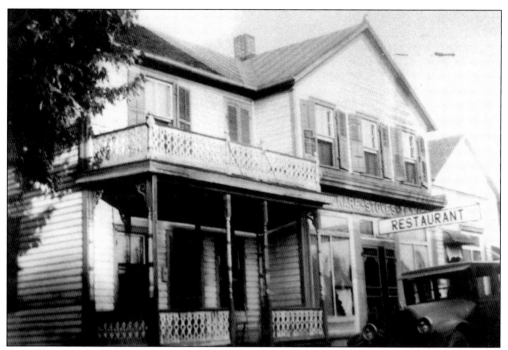

A 1920s scene shows a building on Main Street with a restaurant. In earlier years, it housed the Charles Biel mercantile business. Over the years, different restaurants served Ste. Genevieve at this location. (Pat Parker collection.)

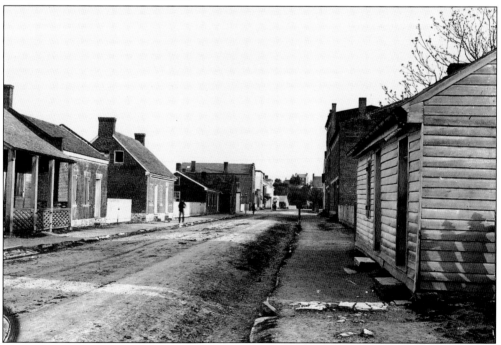

This is a c. 1900 view looking south on North Third Street. With no vehicles in sight and few people, this scene gives a stark, but fascinating view into life in Ste. Genevieve at the dawn of the 20th century. (Missouri History Museum.)

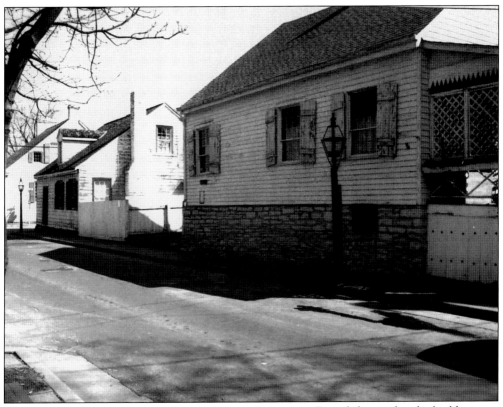

This photograph was taken on Merchant Street facing east. From left to right, the buildings are Felix Vallé, Mammy Shaw, and Theophilus Dufour Houses.

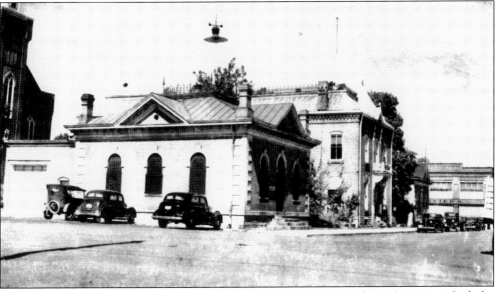

In this 1930s photographic view looking north, one can see a piece of Ste. Genevieve Catholic Church on Fourth Street and the old jail and Ste. Genevieve County Courthouse on Third Street. Farther in the background is the old Rozier's store on Merchant Street. (Pat Parker collection.)

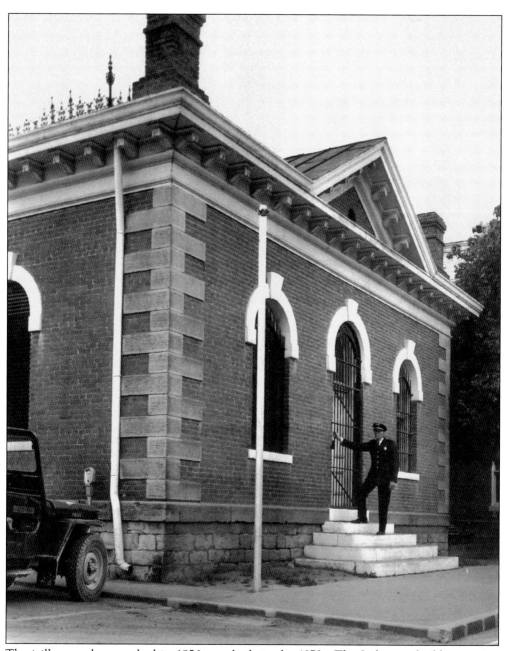

The jailhouse, photographed in 1956, was built in the 1870s. The Italianate building retains its limestone quoins and barred windows. Bars continue to protect the front door. The brick chimneys on the roof corners add to its presence, with a new county jail in Ste. Genevieve. The old jailhouse is used for storage. Police chief Harry Wilder, pictured on the steps, once patrolled St. Louis streets. (St. Louis Mercantile Library.)

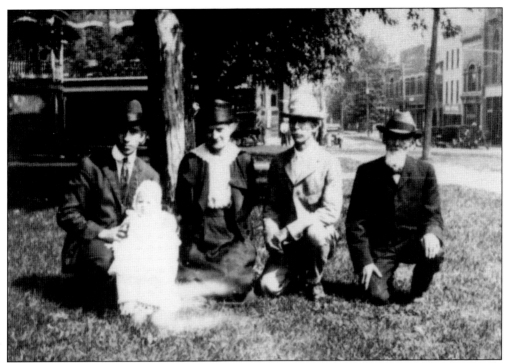

This photograph, taken around 1920, might give a view somewhere in the square. These people are unidentified, but they are probably related over several generations. (Pat Parker collection.)

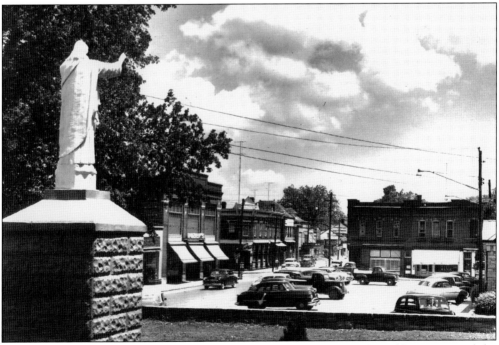

A statue of Christ, photographed in 1953, looks over DuBourg Place, the public square, and the heart of Ste. Genevieve. The square has served as a gathering place for generations. (St. Louis Mercantile Library.)

At the beginning of the 20th century, these gentlemen enjoy the sunny day with good cheer. By this time, people were more relaxed in front of a camera, in contrast to earlier days of photography when most pictures were taken by professionals. By 1912, a few individuals owned Kodak box cameras, and perhaps someone who owned one snapped this picture on Main Street. (Missouri State Archives.)

Five

FAMILY LIFE

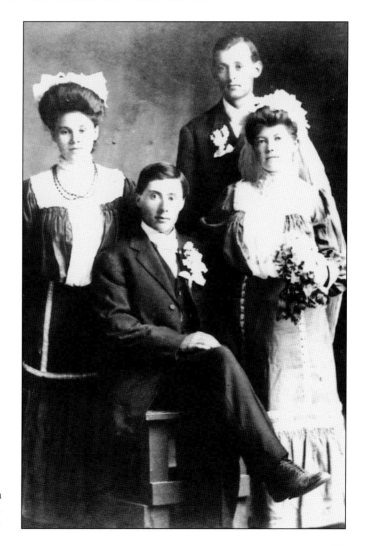

George Joseph Bahr was born in Ste. Genevieve in 1884. He married Catherine (Katie) Bieser, daughter of Ferdinand Bieser and Louisa Ader, in 1908 in Ozora, Ste. Genevieve County. George, who was the son of Martin Joseph Bahr and Theresia Mühlhausler, sits for his marriage picture with his new wife standing to his left. The young woman behind George is his sister, Clara. The best man, Martin Ringwald, stands in the rear. (Becky Millinger collection.)

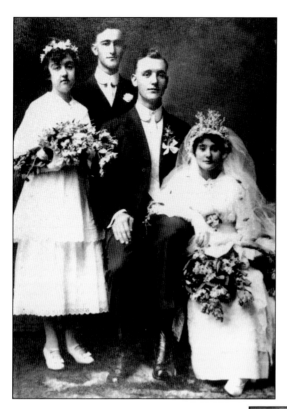

Another wedding, seen here, features Clarence Bates and Elizabeth Bahr. Marie Bahr, a sister to Elizabeth, stands next to the groom, as Art Bates stands behind his brother. This photograph was taken around 1916. (Becky Millinger collection.)

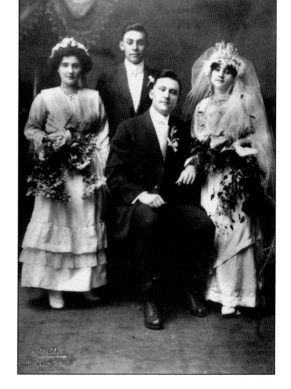

On this day, Theresa Bahr has married into the Lee Pyle family, with Theresa's brother Leo and sister Clara in the back. This photograph was taken around 1916. (Becky Millinger collection.)

George Bahr and Katie Bahr (née Bieser) are standing in back for this photograph for the marriage of his sister Cecelia. (Becky Millinger collection.)

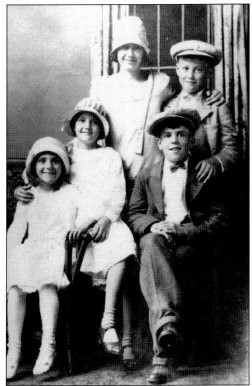

These are the attractive and happy children of George and Katie. They are, clockwise, starting from the bottom, Clara, Marie, Olivia, John, and Joseph. (Becky Millinger collection.)

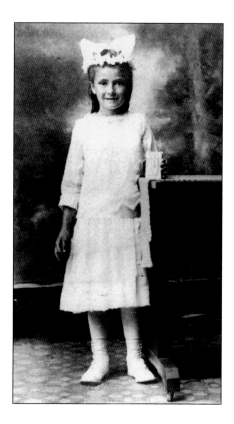

Stella Bahr, who is another daughter of George and Katie Bahr, poses for a picture for her first communion. (Becky Millinger collection).

Ruth Moore is holding Viola Vorst, who is the grandmother of Pat Parker, a current resident of Ste. Genevieve. Moore's first marriage was to a member of the famous William Faulkner family of literary fame. Her second was to William Moore. This photograph was taken around 1890. (Pat Parker collection.)

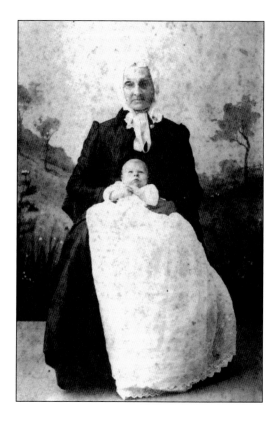

A professional photography studio in Ste. Genevieve sets the scene for this outstanding picture featuring Viola and Anna Vorst with their dog, name unknown. This photograph was taken around 1900. (Pat Parker collection.)

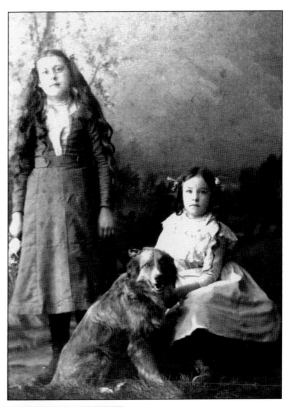

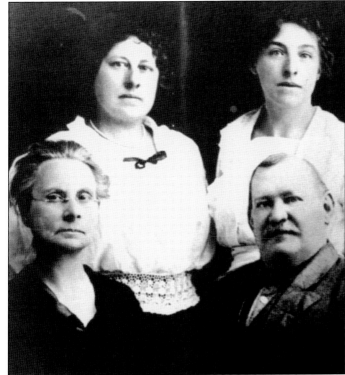

In this photograph are two familiar faces from earlier years. The lady on the left in the rear is Viola Oberle (née Vorst), and the woman on the right is Anna Thomure (née Vorst). The older woman in front is Jennie Vorst. Joe Vorst completes the picture. This photograph was taken around 1920. (Pat Parker collection.)

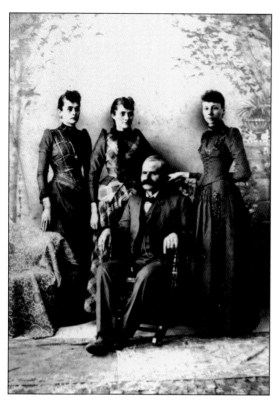

A photography studio background sets the scene for this picture featuring the Biel family. Charles Biel, the patriarch of the family, sits surrounded by his daughters. Charles was one of the founders of First Presbyterian Church, and he also served as its first deacon. Francis is to the left, Minnie is in the center, and Jennie (the great-grandmother to Pat Parker) is on the right is. This photograph was taken around 1890. (Pat Parker collection.)

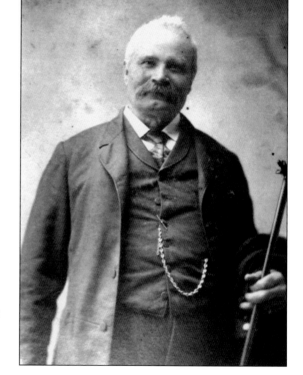

In his lifetime, Charles Biel, a businessman, church leader, husband, and father, contributed to the success of Ste. Genevieve, and he has left a strong legacy. This photograph was taken around 1900. (Pat Parker collection.)

Jennie Vorst is the second lady from the right in the last row. Anna Vorst is the young woman in the center of the first row. The blond-headed boy next to her is Frederick Petriquin, who acquired great wealth from his lime company in Ste. Genevieve. He was an early member of First Presbyterian Church and for a time was president of the Lions Club. This photograph was taken between 1910 and 1915. (Pat Parker collection.)

Bernadine Oberle sits for a picture with her grandchildren. Her husband owned Oberle Sausage, a business still active in the area. The children are, from left to right, Butch, Helen, Bernadine, Hazel, and Lilburn. This photograph was taken around 1920. (Pat Parker collection.)

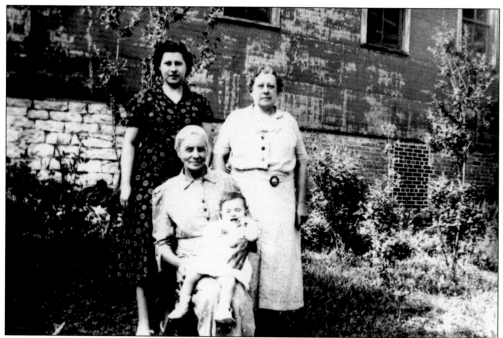

The woman standing on the right is Viola Oberle (née Vorst), the baby held by Ruth Moore in a previous picture. Jennie Vorst is holding the baby, the daughter of Anna Ruth Henson, who is standing behind them. The baby is Pat Henson, who lives today in Ste. Genevieve as Pat Parker. This photograph was taken around 1938. (Pat Parker collection.)

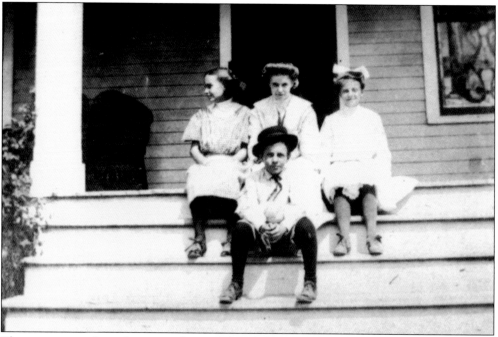

These young people, perhaps a mother with her children, are having a picture taken by a friend or relative or perhaps by a roving professional photographer of the day. At this early date, few individuals owned cameras. This photograph was taken around 1890. (Pat Parker collection.)

Six

CHURCHES AND SCHOOLS

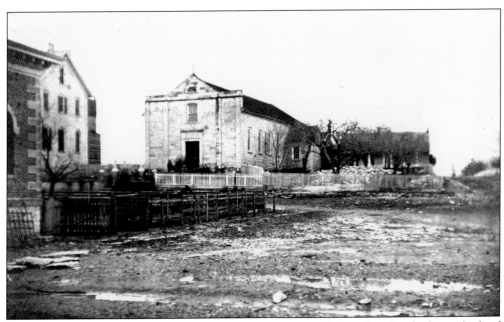

This *c.* 1870 photograph shows the 1831 Ste. Genevieve Catholic Church, which was built of stone and was known as the "Rock Church." It was built under the supervision of Rev. Francis Dahman. This building had replaced a log timber church from 1795, which in turn had replaced a first log timber church. (Missouri History Museum.)

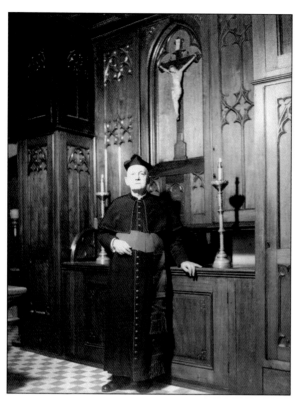

The Very Reverend C. L. Van Tourenhout, photographed in 1935, led the Ste. Genevieve parish from 1901 into the mid-20th century. The pastor and Ste. Genevieve Catholic Church played prominent roles in the 1935 bicentennial celebration. However, it is now widely accepted that 1735 is not the year in which Ste. Genevieve was settled by the French. Historian Carl J. Ekberg appears to have made his case that the late 1740s is the correct period. (National Archives.)

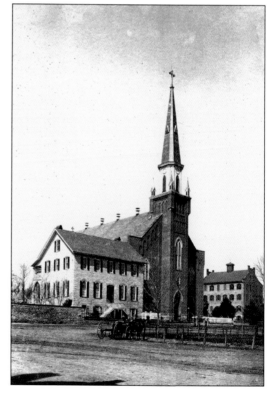

In 1876, as services continued in the Rock Church, construction on the new church enclosed the old building. This Gothic Revival building of the church at 51 Place Dubourg was dedicated in 1880. On occasion there were sermons in English, French, and German. (Missouri History Museum.)

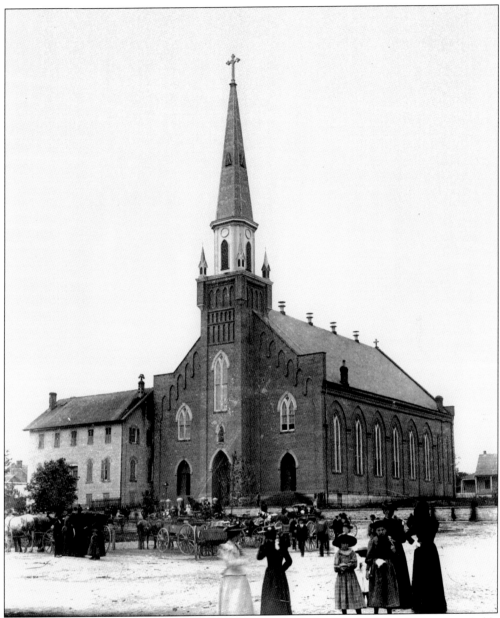

In this c. 1905 photograph, the church can be seen from Market Place or Place Dubourg probably after the conclusion of a mass, as people are walking toward the camera and away from the church. (Missouri History Museum.)

A c. 1900 photograph shows the church to the far left and the old school in the foreground. It shows an orchard of some type at the rear of the building. (Missouri History Museum.)

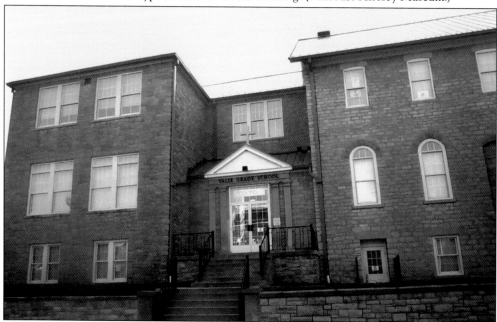

Fr. Francis Xavier Weiss presided over the construction of "Old Vallé School" in 1865. After failing to establish a college in the building, Weiss used it as a rectory. In 1924, it became Vallé High School. The section on the left was built in 1937. Today the two sections function as Vallé Grade School.

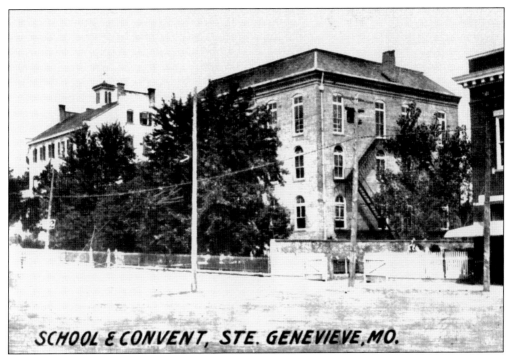

SCHOOL & CONVENT, STE. GENEVIEVE, MO.

The building on the left, photographed in the 1940s, is the old convent. In 1849, Loretto nuns had moved into the former home of Joseph Pratte until 1959, when the Sisters of St. Joseph were given control of Vallé Schools. The old grade school (on the right) was built in 1893 and was torn down with the convent in 1958. (Pat Parker collection.)

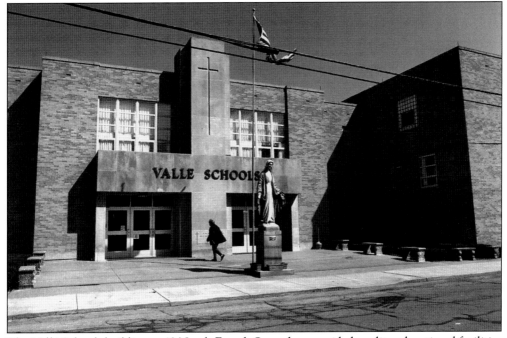

The Vallé Schools building at 40 North Fourth Street has provided quality educational facilities for Catholic youth since 1955.

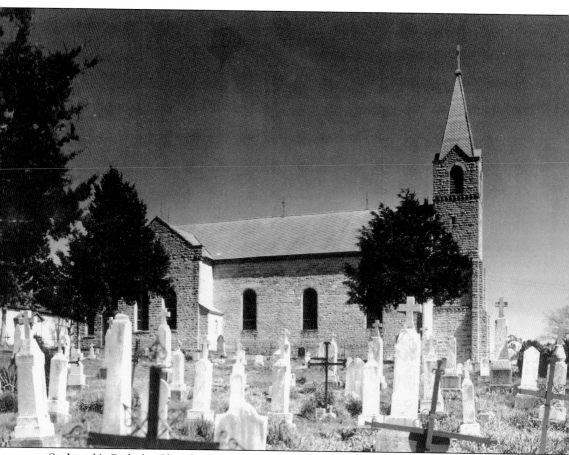

St. Joseph's Catholic Church, photographed in 1937, is another important church. Early in the 19th century, Germans began to settle in the Ste. Genevieve region, drawn to the rich farmland and commercial opportunities. They joined in ever-greater numbers with the French habitants and Anglo-Americans. Whereas most French were Catholic, Germans were both Catholic and Protestant. (NPS.)

Holy Cross Lutheran Church members met for services in their homes beginning in 1867 and until they completed this church building on Market Street in 1875. The church primarily served people of German descent, and today it still has an important role in Ste. Genevieve religious life.

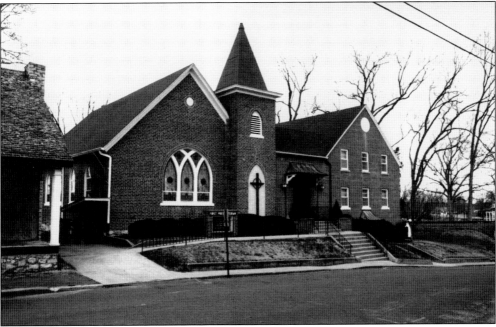

First Presbyterian Church and its annex at 160 South Main Street were built in 1904 and 1954, respectively. An all-brick Gothic Revival church, it features an arched stained-glass window and a tower with a witch's hat roof. The church is connected to the annex education building by a front gabled block.

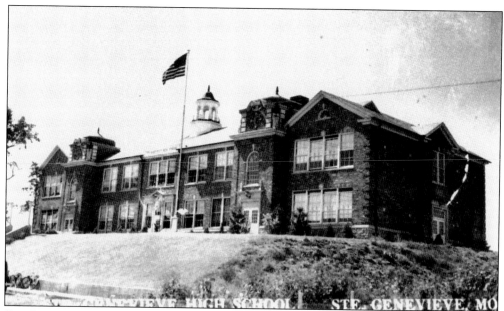

Ste. Genevieve High School, photographed in the 1950s, opened in 1936 on grounds that had been part of the Old Louisiana Academy estate. A Colonial Revival building, it features gables, fanlights, and a cupola. The firm of Bonsack and Pearce designed the school as a WPA project. In the 1960s, a new school was built a block away, and the old building became the junior high school. (Pat Parker collection.)

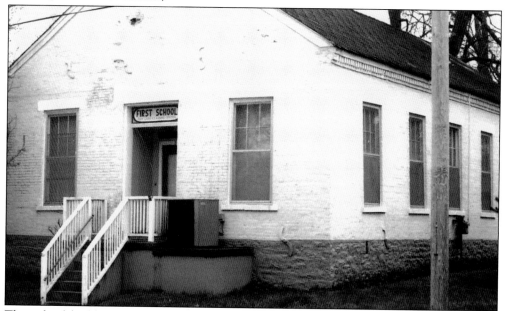

This school building was constructed in 1859 and has been called the first public school in Ste. Genevieve. However, the Old Louisiana Academy was built in 1808 and was said to be the first public school in the Louisiana Territory. Questions often arise when dating firsts. It sometimes comes down to semantics. When the academy was built, private schools were often called public schools. This building became the black school in 1894. Today it is used as a day care.

Seven

COMMERCE AND INDUSTRY

Several miles from the Mississippi River, ancient limekilns, such as this one photographed in 1937, remain from early French efforts in lime burning. These early families passed their knowledge, and methods, through many generations. (NPS.)

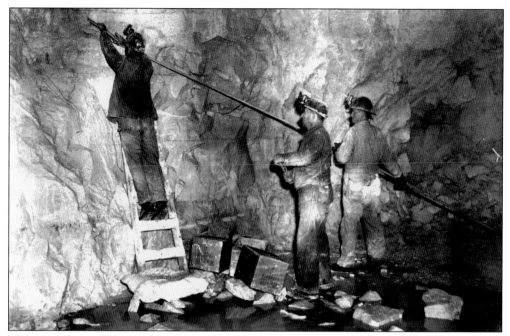

Mississippi Lime Company continues to produce massive amounts of lime for industry. Three lime workers, photographed around 1950, push dynamite charges 15 feet into a hole drilled into the rock. Blasting is done when other men are not near or under the mine. Trucks take the limestone chunks to a primary crusher. (St. Louis Mercantile Library.)

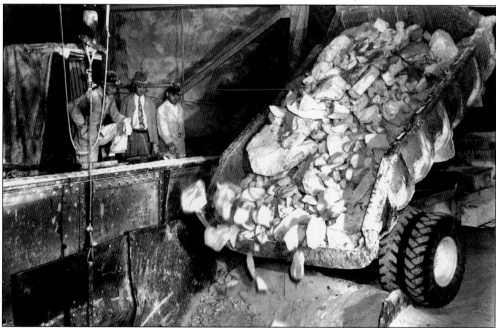

For many years, Ste. Genevieve has been the largest lime-producing area in the world—the lime is over 99 percent pure calcium carbonate. This truck, photographed in the 1950s, is unloading limestone into the primary crusher. From this crusher, the stone will go to other crushers to reduce it to still smaller sizes to be burned in rotary kilns. (St. Louis Mercantile Library.)

This photograph was taken about 1900. Through the centuries, quarry workers have had a heavy and difficult task. Advances in technology and machinery through the 20th century have eased the pressure on the workers but not the wetness and grime of the job. Beginning in 2009, Holcin Inc. will begin to turn limestone into cement and will become the largest cement plant in the country. (Missouri State Archives.)

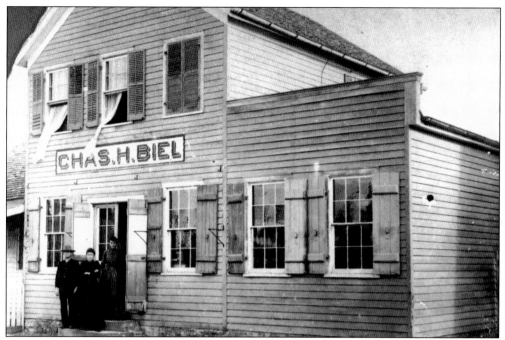

Charles Biel was born in Germany and immigrated to the United States in 1853. He operated a mercantile business on the first floor, and he and his family probably lived upstairs. Photographed around 1890, it is believed that Charles is shown with his wife and one of his daughters. (Pat Parker collection.)

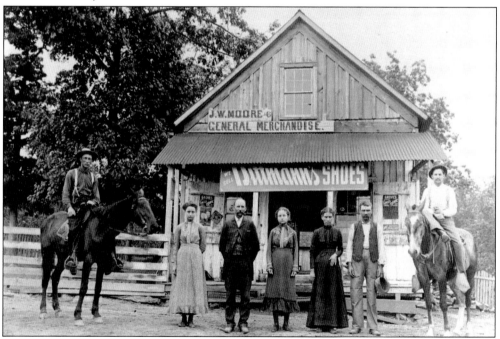

Imperial View Company out of Nashville, Tennessee, took this c. 1901 picture at Womack, a small settlement in Ste. Genevieve County. They are members of the Moore and Womack families. (Nancy C. [Cathy] Hill collection.)

Hotel Ste. Genevieve at 1 North Main Street is the place to visit first for some who come to Ste. Genevieve. Many stay overnight and dine in the restaurant, and others stay only for a meal. It is only a few minutes walk to some of the town's most famous houses. The building was constructed between 1900 and 1910 with bricks on a foundation of limestone blocks. The entrance is on Merchant Street with two other entries on Main Street.

The Dufour-Rozier Building at 201 Merchant Street sits across the street from the Mammy Shaw House. Parfait Dufour arrived with Ste. Genevieve's first settlers and eventually bought the lot. A trading firm erected the building as an office and warehouse in about 1818. In later years, Henry L. Rozier Sr. bought it for use as a bank.

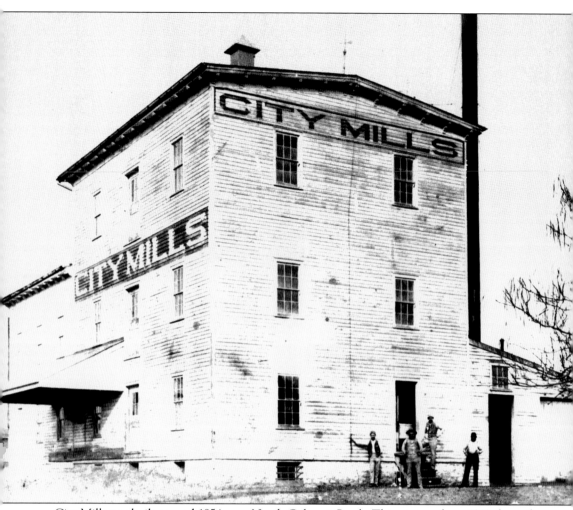

City Mills was built around 1854 near North Gabouri Creek. This picture from 1910 shows four men; two are identified as George Wehner and August Wehner. George and a man named Bolle were each part owners for an unknown period of time. It was destroyed by fire around 1962, and the great 1993 flood swept away some remnants of the building. (Missouri State Archives.)

The Mary E. Kern Building at 289 Merchant Street is a wood-framed structure with a well-preserved 19th-century facade. Meyers shoes displays Red Wing Shoes in this 1893 Victorian building.

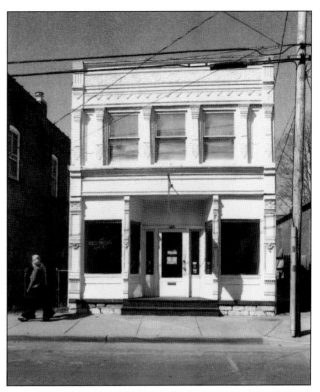

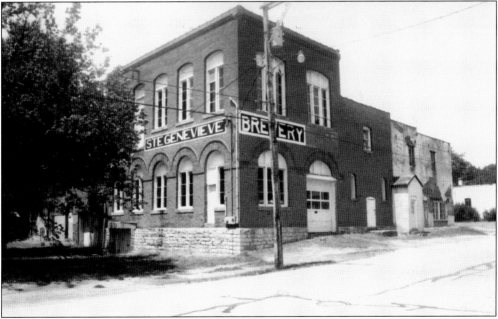

Valentine Rottler first built a brewery building in 1883, which was heavily damaged by a major fire in 1886. By 1888, the brewery was rebuilt. In recent years, attempts have been made to restore the Ste. Genevieve Brewery, and there has been some improvement in the exterior of the building, which awaits a tenant. It abounds in potential benefit for Ste. Genevieve if the owners and neighbors can agree on a use. It is located a 555 North Third Street.

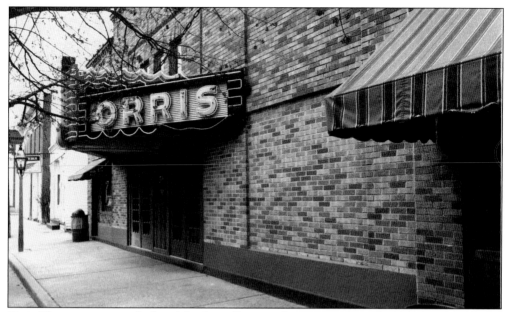

Orris Theater is easy to find on Merchant Street with its neon sign asking for attention. This 1932 theater building flourished during the Great Depression when people needed an escape from life and where people could identify with beautiful people and dreams of wealth and glory on the screen. Theaters such as the Orris showed these dreams in many cities in the United States through World War II and the 1940s to the early 1950s, and then they began to disappear as stores or new construction. ColeBeanBay company is presently bringing theatrical classics to the Orris during the summer. Sirros Restaurant is next door.

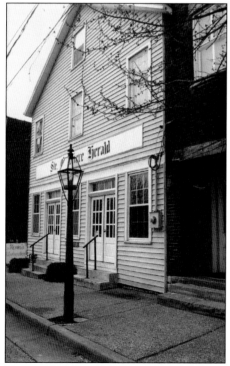

The Ferdinand Roy Building at 330 Market Street is known locally as the Ste. Genevieve Herald building. This structure goes back to around 1865. It is a front-gabled, wood-framed, and brick-nogged commercial building that presents an attractive image. A fixture in town since 1882, the Ste. Genevieve Herald has occupied the Roy Building since early in the 20th century.

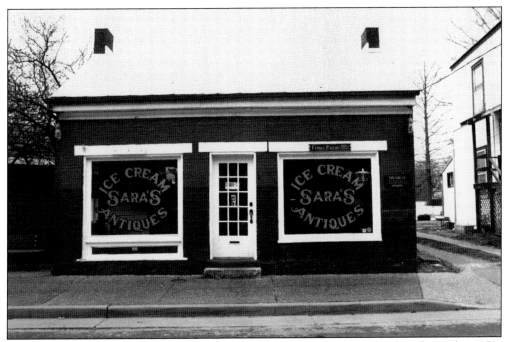

Reputedly Gen. Firmin A. Rozier had this building constructed for his law firm. The 1850s German brick building has housed Sara's Ice Cream and Antiques for 30 years. Coffee is 10¢ a cup. Refills are free.

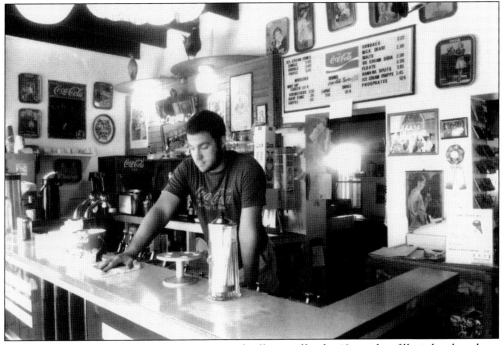

Besides taking one back to an earlier time and selling coffee for 10¢ with refills, it has hot dogs, sodas, malts, and good cheer. The counter is from Old Orchard Drug Store in Webster Groves. Seen here is Adam Hermann at work.

Candle's Corner is a popular tourist destination for those who like candles of many shapes, sizes, and scents. The business occupies the Forian Huck Building, also known as the Okenfuss Building, at 302 Market Street. A distinctive feature of the c. 1860 building is the angled corner entrance.

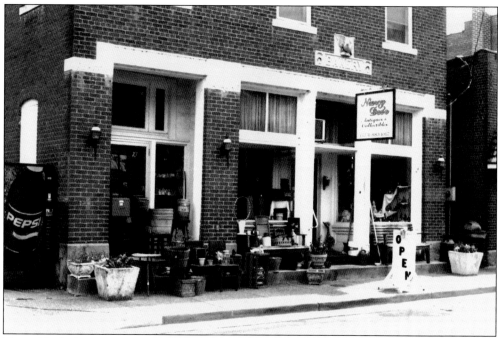

Nancy Dee's Antiques occupies this commercial building at 252 Merchant Street. A cast stone eagle perches over the doorway along with a Bakery sign, the designation of the building's first use beginning in 1908, and the north-facing wall is an early 20th-century feature.

This two-story brick commercial building at 286–288 Merchant Street, photographed around 1910, retains its mostly original storefront with cast-iron ornament. The recessed central doorway invites one to enter. Above the second-story windows extends a corbelled stringcourse.

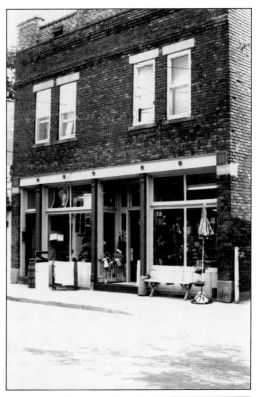

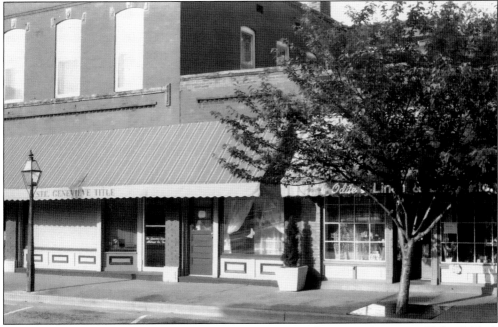

Third Street on the square supports several businesses, such as Ste. Genevieve Title, Odiles's Linen and Lace, Anvil Restaurant, Armbruster Realty Company, the Old Brick House, and the Southern Hotel. These enterprises together create a strong mercantile core of historic buildings representative of the 19th century.

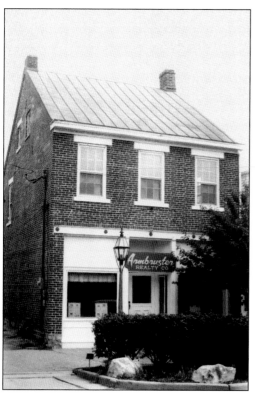

Armbruster Realty Company does business from the Augustus Wilder Building at 70 South Third Street. Rutledge Drug Store had dispensed medicine from this location for many years. The c. 1860 brick structure has two and a half stories and is side gabled. Its iron lintel over the front door and windows is a distinctive feature.

The Augustine Menard Building at Main Street, photographed around 1990, dominates the corner across from the Ste. Genevieve Hotel. The north wall is covered with an assortment of inconsistently placed and sized windows and a door on the second floor stirs questions about its purpose. In earlier years, the building had served as a shoe factory and as a general mercantile store. In those days, a pulley above the door allowed for an easy delivery of merchandise materials. Today this Victorian commercial building houses the Show-Me Shop. (Missouri State Archives.)

Eight

PLACES OF INTEREST

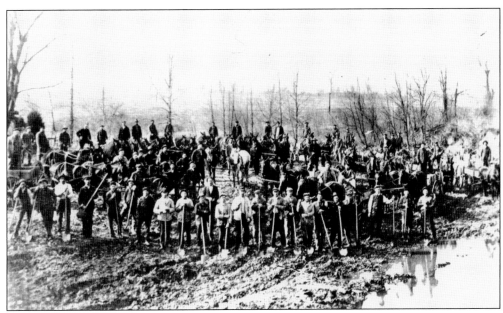

One of Missouri's first roads ran through the new village of Ste. Genevieve. In the early 20th century, many communities, including Ste. Genevieve, were poorly connected with other towns. Although Ste. Genevieve did have train service and the Mississippi River for travel and commerce, the building of roads for carriages, wagons, and automobiles, without question, was a leap into the future. This photograph was taken around 1900. (Missouri State Archives.)

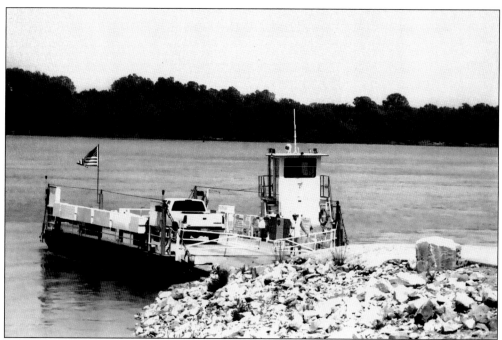

The automobile ferry remains in operation. The closest bridge is 20 miles to the south, and the Ste. Genevieve-Modoc Ferry itself is a convenient and enjoyable way to get to the other side of the Mississippi River. The east side of the river offers other ancient settlements, such as Kaskaskia, Fort Kaskaskia, Prairie du Rocher, and Fort de Chartres. These settlements and forts were important predecessors to Ste. Genevieve.

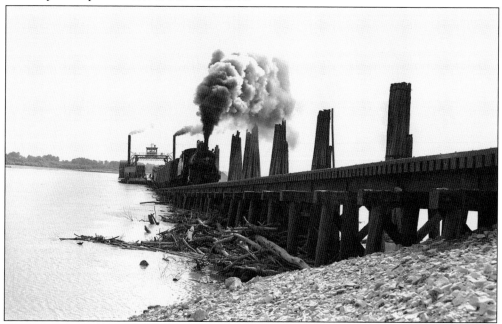

A railroad ferry takes a loaded Missouri-Illinois Railroad freight train across the Mississippi River at Ste. Genevieve around 1950. Repeated trips were required for long trains. (Gerald R. Massie Photo Collection, Missouri State Archives.)

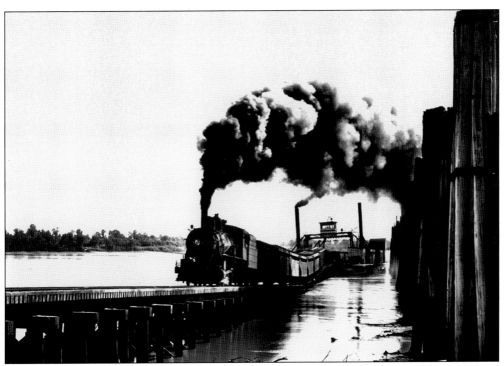

A closer shot at a different angle shows the power of the engine and the genius of the procedure. The train ferry was the last in the area. (Gerald R. Massie Photo Collection, Missouri State Archives.)

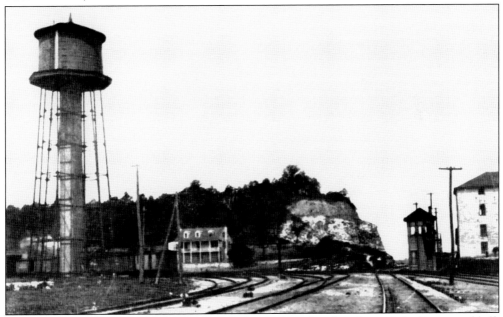

The presence of the Placet-Vallé House near the active railroad tracks and the limestone bluffs (Little Rock) helps to date this photograph as no later than 1936. In 1936, the house was destroyed by a fire that the Ste. Genevieve Fire Department refused to extinguish because it was outside city limits. (Pat Parker collection.)

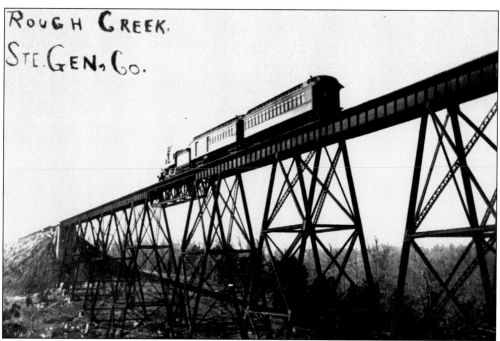

Rough Creek in Ste. Genevieve County is the location of this dramatic 1930s photograph of a steam locomotive engine pulling two passenger cars high above the valley. (Pat Parker collection.)

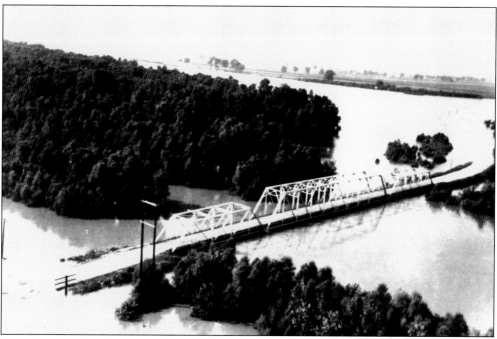

Over the years, Ste. Genevieve County has had many floods involving the Mississippi River. This unidentified bridge, photographed in the mid-20th century, is almost covered with floodwaters to its deck. Many dikes and levees have been built to keep the river within its banks, but sometimes these constructions are breached. (Pat Parker collection.)

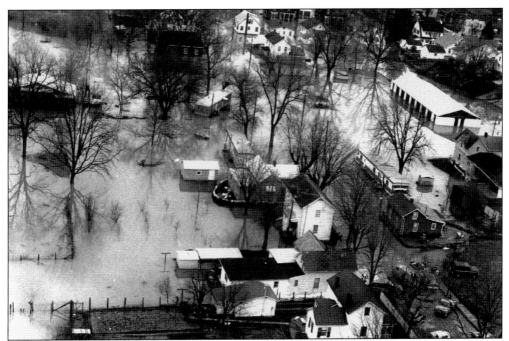

An aerial photograph taken in 1983 shows flooding. During the great flood of 1993, television stations broadcast coverage around the world. The French watched in horror as the waters licked at the edges of houses their ancestors had built 200 years before. Millions watched as volunteers stacked sandbags to hold back the tide. Today flood walls protect much of Ste. Genevieve. After the flood, the French Heritage Relief Committee was organized, and it proposed a French heritage park. (St. Louis Mercantile Library.)

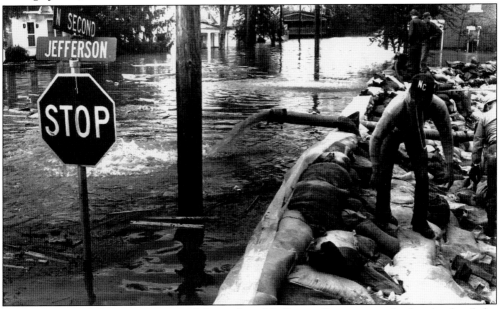

A close view of the intersection of Second and Jefferson Streets reveals the depth of the floodwater as volunteers pack more sandbags to hold back the waters in 1983. (St. Louis Mercantile Library.)

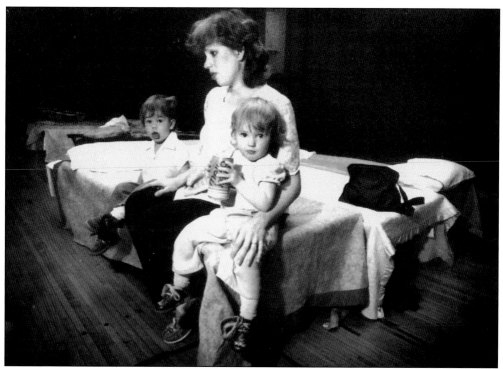

In the 1983 flood, Diana Flath and her children find shelter and beds in the basement of the Ste. Genevieve City Hall. (St. Louis Mercantile Library, John Dengler.)

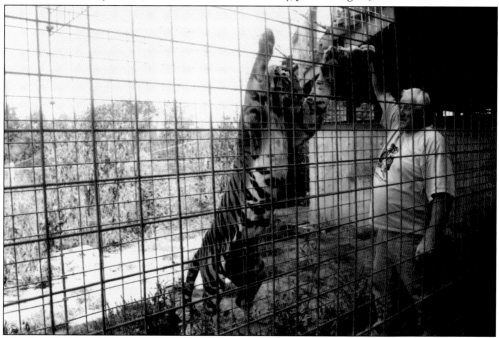

The National Tiger Sanctuary provides a natural habitat for tigers on 450 acres of rolling Ozark Hills in Ste. Genevieve County. On a feeding tour, Keith Kinkade feeds a chicken dinner to Max. On the tiger keeper tour, a guest gets to feed a tiger. Fees support this nonprofit organization.

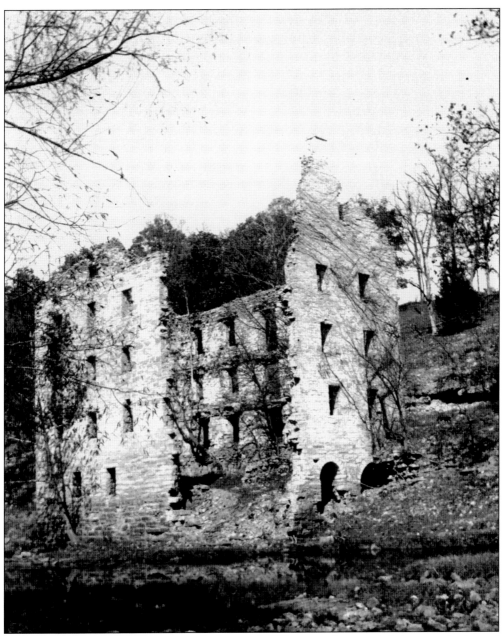

Although the "Burnt Mill," photographed around 1937, is outside town, it belongs to the legend and lore of Ste. Genevieve, which claims that the old mill was set on fire when the Civil War raged across Missouri. (NPS.)

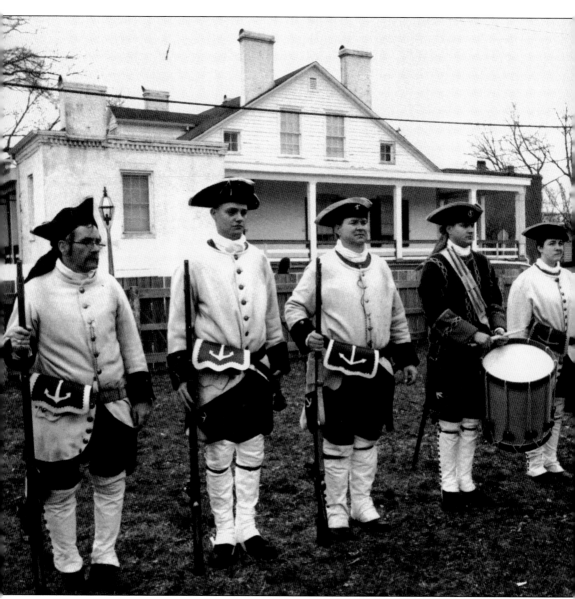

These French marines parade and fire their muskets behind the Bolduc-LeMeilleur House and with the Francois Vallé House in the background. The occasion is the award ceremony honoring Ste. Genevieve as one of the "dozen distinctive destinations" in the United States. The National Trust for Historic Preservation presented the award. The March event was one of many scheduled for Spring into Ste. Genevieve.

Nine

RESTORATION

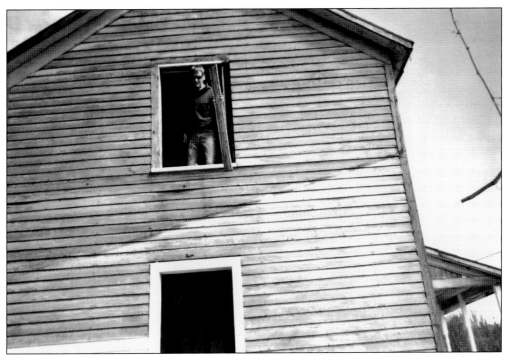

Jim Beckerman stands on the second floor of the James Brooks House where he works on a window jamb in 2007. He restores or works on houses of different styles and periods when owners need someone with special skills and experience for their historic buildings. (Jim Beckerman collection.)

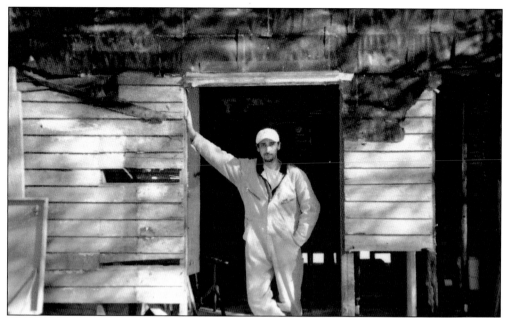

The Brooks House at 308 St. Mary's Road was built in 1861. It had sustained extensive damage in the massive flood of 1993, and after the water receded, members of the Brooks family were planning to demolish it, but preservationists persuaded them to restore the historic house. (Jim Beckerman collection.)

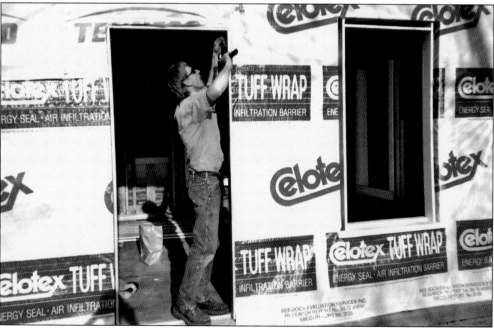

In this photograph, insulation has been installed, and Jim Beckerman is working on the doorjamb in preparation for new walls. House construction in the 19th century rarely included insulation. Even in restoration work, considering the high costs, and if the building is going to be occupied, it is important to save costs on heating and cooling. In buildings being restored to serve as a museum, it may be acceptable to forego extensive insulation work. (Jim Beckerman collection.)

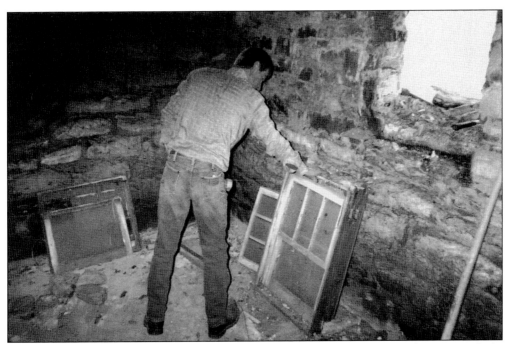

Here an ancient stone foundation and basement needs some repair work involving water leaks and windows. A decision will be made concerning whether the windows will be replaced. (Jim Beckerman collection.)

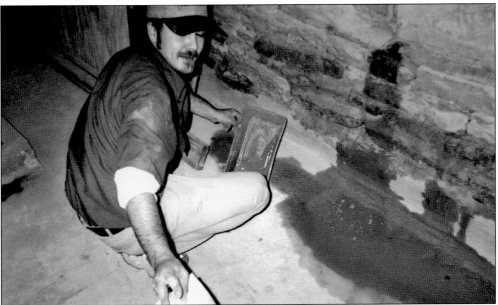

A major water leak, any homeowner knows, can be difficult to seal. Restoration is generally more exacting than renovation. Whereas restoration requires correct detailing down to hardware suiting the type of house and its period, during renovation the building is not taken back to its original condition. Extensive liberties are taken in a sort of construction, creating a building with the old basic structure. A case can be made for restoration or renovation. (Jim Beckerman collection.)

Restoring a historic building requires concentration and dedication. This 1861 frame house is smaller than many restoration projects, but the heavy flood damage required extensive replacement of important sections and a lot of tearing away of alterations over the years. In contrast to the old days when only primitive tools were available for construction, which required many hours of labor, modern equipment makes it easier, faster, and less expensive. There are those rare individuals who work only with the original, ancient tools and only with original or exact replicates and with the same materials, such as blown glass for windows instead of modern produced glass. This type of restoration is pricey and time-consuming and most of the time is not done. (Jim Beckerman collection.)

Now the home of William Brooks, a well-known Ste. Genevieve resident from 1889 to 1984, when he died, is restored closely to its 1861 image. Having survived vacancy since 1984 and the flood of 1993, it will become a cultural heritage museum.

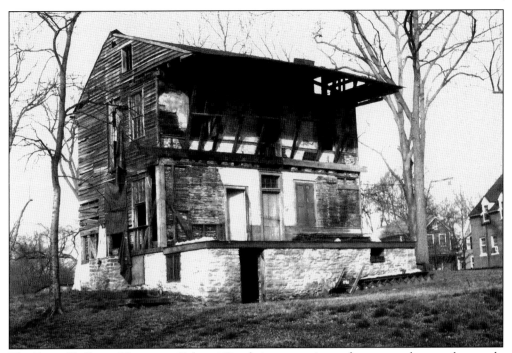

The Ratte-Hoffman House on Gabouri Road sits on a piece of property that until recently served as a cemetery for junk cars and other assorted debris. The house, built around 1809, has received a reprieve from the Hoffman family. They are restoring this ancient dwelling.

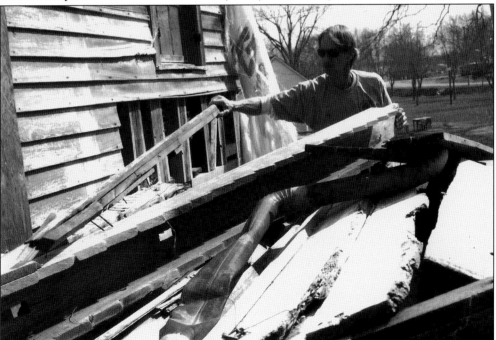

Jim Beckerman searches for remnants of the house, which could be used in its restoration. This heavy-timber frame house had not been altered over almost two centuries, leaving it in its original form with a lot of deterioration. Restoration should undercover few surprises.

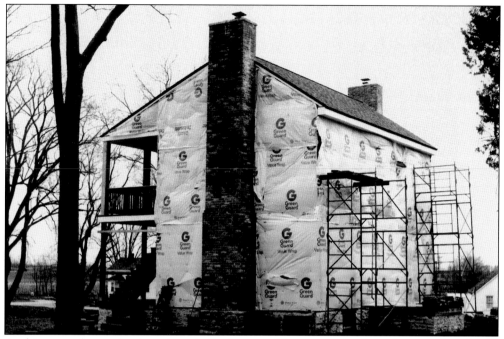

At this stage, the porches have been built, the two chimneys are in place, the stone foundation is renewed, and insulation is waiting for new clapboards.

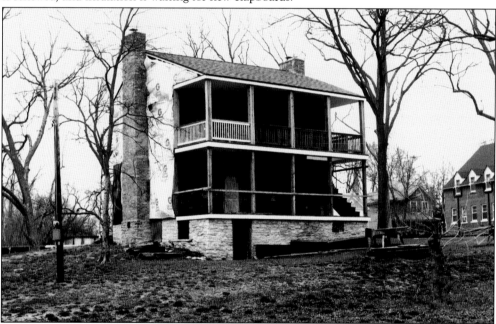

The Ratte-Hoffman House, a superb example of an early Anglo-American house, once owned by John Scott (the first United States representative from Missouri) and believed to have served as a stagecoach station in the 1800s, will be reclaiming its history. Perhaps in future years, more 18th- and 19th-century houses currently hiding behind vinyl or asbestos siding will reveal their secrets and the charms of their ancient past and take their place among the French Colonial, German Victorian, and Anglo-American houses in Ste. Genevieve.

BIBLIOGRAPHY

Bushnell, David I., Jr. *Archeological Investigations in Ste. Genevieve County, Missouri*. Washington, D.C.: Government Printing Office, 1914.

Ekberg, Carl J. *Colonial Ste. Genevieve*. Tucson: Patrice Press, 1996.

Evans, Mark L. *The Commandant's Last Ride*. Cape Girardeau, MO: Ten-Digit Press, 2001.

Franzwa, Gregory M. *The Story of Old Ste. Genevieve*. Tucson: Patrice Press, 1998.

Naeger, Bill, Patti Naeger, and Mark L. Evans. *Ste. Genevieve: A Leisurely Stroll through History*. Ste. Genevieve, MO: Merchant Street Publishing, 1998.

Peterson, Charles E. *Colonial St. Louis: Building A Creole Capital*. Tucson: Patrice Press, 2001.

Platisha, Rev. J. B., C.M., M.S. *Ste. Genevieve Bi-Centennial Celebration and Pageant: The Mother of the West*. Cape Girardeau, MO: Missourian Printing and Stationery, 1935.

DISCOVER THOUSANDS OF LOCAL HISTORY BOOKS FEATURING MILLIONS OF VINTAGE IMAGES

Arcadia Publishing, the leading local history publisher in the United States, is committed to making history accessible and meaningful through publishing books that celebrate and preserve the heritage of America's people and places.

Find more books like this at
www.arcadiapublishing.com

Search for your hometown history, your old stomping grounds, and even your favorite sports team.